Old Forge
Gateway to the Adirondacks

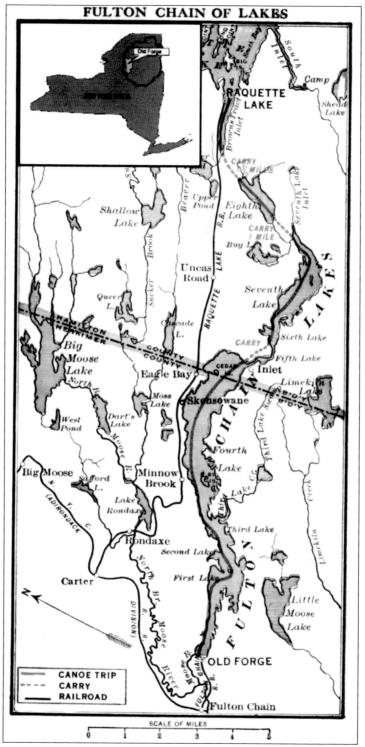

FULTON CHAIN OF LAKES

South Inlet

Camp

RAQUETTE LAKE

Shedd Lake

Browns Tract Inlet

CARRY 1½ MILES

Seventh Lake Inlet

Upper Pond

Eighth Lake

Beaver

R.R.

CARRY 1 MILE

Shallow Lake

Bug L.

Sucker Brook

Uncas Road

RAQUETTE LAKE

Seventh Lake

Queer L.

Cascade L.

CARRY

Sixth Lake

HAMILTON / HERKIMER

COUNTY / COUNTY

Big Moose Lake

CARRY

Fifth Lake

North B.

Eagle Bay

CEDAR IS.

Inlet

Limekiln Lake

Moss Lake

Skensowane

CHAIN

Third Lake Station

West Pond

Dart's Lake

Moose R.

Third Lake Cr.

Big Moose

Safford L.

Minnow Brook

N. Y. C. (ADIRONDACK)

Fourth Lake

Lake Rondaxe

Big Lake

Third Lake

Limekiln Creek

Rondaxe

Second Lake

North Br. Moose River

Carter

First Lake

FULTON

Little Moose Lake

N

DIVISION R. R. R.

OLD FORGE

Moose R.

FULTON CHAIN R. R.

CANOE TRIP
CARRY
RAILROAD

Fulton Chain

SCALE OF MILES

0 1 2 3 4 5

Old Forge is located in the Town of Webb in northern Herkimer County. This map depicts the region surrounding Old Forge and the Fulton Chain of Lakes in 1915.

POSTCARD HISTORY SERIES

Old Forge
Gateway to the Adirondacks

Linda Cohen, Sarah Cohen, and Peg Masters

ARCADIA

Published by Arcadia Publishing
Charleston SC, Chicago IL, Portsmouth NH, San Francisco CA

Printed in the United States of America

Library of Congress Catalog Card Number: 2002116955

For all general information contact Arcadia Publishing at:
Telephone 843-853-2070
Fax 843-853-0044
E-mail sales@arcadiapublishing.com
For customer service and orders:
Toll-Free 1-888-313-2665

Visit us on the Internet at http://www.arcadiapublishing.com

This picturesque postcard dates from the 1930s.

CONTENTS

ACKNOWLEDGMENTS

This book has been made possible by the generosity of many people. The Town of Webb Historical Association in Old Forge lent us its extensive postcard collection and the use of its offices throughout the production. All royalties from the sale of *Old Forge: Gateway to the Adirondacks* will be donated to this venerable organization.

Charlie Kiefer, collector extraordinaire, lent postcards and wisdom, without which we would have been much less knowledgeable. Derwin "Doc" Jones and Ida Winter also provided us with postcards from their extensive collections.

Postcard production has been a regional industry since the late 19th century. Henry and Harry Beach, Glenn & Company, the Kiefer Company, and the Standard Supply Company of Otter Lake are among those whose cards are included in this book. Standard Supply Company still distributes its images; so, we are particularly grateful for its participation in this project.

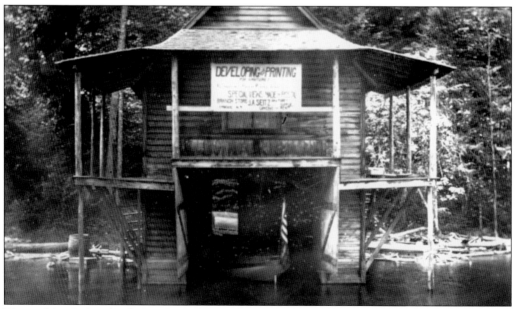

Pictured is J.A. Seitz's advertising card for the Fourth Lake Boathouse Photography Studio.

INTRODUCTION

The Adirondack Mountains are among the oldest rock formations on earth, having pushed up through the earth's surface some billion years ago. The survival of the mountains throughout the ice ages and climate warming has defined the landscape, creating gentle slopes, lakes, and streams throughout the North Country. Human occupation has, by comparison, been only short-term, beginning in the 18th century.

Old Forge and the Fulton Chain of Lakes, like most of the North Country, was an area used for seasonal fishing and hunting by regional Native Americans. The climate was too forbidding for year-round habitation. Today, that has not changed; however, we have down vests, fleece jackets, flannel-lined trousers, and R-40 insulated houses to protect us during the bitter winter season.

Old Forge is located along the middle branch of the Moose River at the beginning of the Fulton Chain of Lakes. The eight lakes of the chain are interconnected by channels and carries (portages) for a distance of 25 miles. The northern branch of this great river begins at Big Moose Lake, flows through Dart's and Rondaxe Lakes, and joins the middle branch just south of the hamlet of Old Forge. The wildest section of the Moose River, the south branch, flows from the Moose River Plains above Limekiln Lake through the privately owned Adirondack League Club (ALC) and links up with the main body at McKeever.

According to a U.S. Geological Survey in 1892, the tributaries of the Moose River were connected to 107 different bodies of water. "By now the beaver have gotten to work and that number may have doubled," speculated author David Beetle in 1948. This vast watershed was purchased in 1798 by John Brown of Providence, Rhode Island, a prosperous and philanthropic businessman after whom Brown University was named. He built the first roads into the region and established a gristmill, a sawmill, and a dam near the future Old Forge waterfront. Brown's plans for the development of his 200,000 acres, known to this day as John Brown's Tract, were abandoned following his death in 1803. Charles Frederick Herreshoff, John Brown's son-in-law, assumed charge of the Tract in 1811.

Early efforts to clear the wild forestland for farming proved futile due to thin, rocky soil and a short growing season. Raising sheep failed because of attacks by wolves. Settlers fled faster than they could be recruited. Herreshoff built an iron forge, but the ore was of poor grade and the mine flooded. Deeply in debt, he committed suicide in 1819.

Over the next 50 years, very little settlement occurred. Hunters and fishermen continued to explore. Following the Civil War, outdoorsmen began guiding "sports" on expeditions to hunt and fish along the three branches of the Moose River. The road from Boonville was improved, and soon a buckboard could make the trip in less than eight hours.

Fulton Chain (renamed Thendara in 1920) and Old Forge grew at the locations where the first Brown's Tract settlements had originated. Guides referred to the place where Herreshoff had located his forge as Old Forge. Dr. William Seward Webb's Adirondack and St. Lawrence Railroad, also called the Mohawk and Malone, arrived in Fulton Chain in 1892. Built at a cost of nearly $5 million of Webb's wife Eliza Vanderbilt's inheritance, the 191-mile railroad connected the Mohawk Valley to the lucrative St. Lawrence trade routes. The following year, Webb sold the railroad to the New York Central. Soon, a two-mile spur was built to the Old Forge waterfront, where passengers could disembark and stay at the Forge House Hotel or board steamboats to continue on to resorts and camps along the lakes. In 1896, the jubilant citizens of Old Forge successfully petitioned their

legislators to rename the northernmost section of Herkimer County the Town of Webb. The township is spread out over 466 square miles and is the largest township in New York State.

Passenger and freight trains rolled through the mountains daily in the 1890s, and development and settlement sped along at a fast pace. The little hamlets of McKeever, Fulton Chain, Old Forge, Big Moose, Eagle Bay, and Inlet grew. Hotels and resorts attracted many sportsmen and other visitors. Private camps proliferated, and guests came from all over the country. In 1895, Pres. Benjamin Harrison, after leaving Washington, built a camp on Second Lake, to which he came from Indianapolis each summer until his death in 1901.

Tourism and logging continued to grow through the 1920s but, like most of the country, slowed during the Great Depression. In the 1930s, winter sports became popular, and the 1950s saw the creation of the Enchanted Forest theme park for summer visitors. The trains disappeared, and improved roads and automobiles made the area accessible to many new people. Today, more than half a million visitors come to the area annually, but only 1,900 hearty folks call it home. Welcome to this enchanting part of the North Country.

One

TRANSPORTATION

There are only two roadways into the Old Forge region today: the state highway Route 28 and the Number Four Road through the Stillwater Reservoir area. John Brown of Providence, Rhode Island, and his descendants carved out both routes more than 200 years ago. The main route, called the Brown's Tract Road, entered the wilderness from the south and roughly followed the northeasterly flow of the Moose River. The Number Four Road entered the Tract from the west through neighboring Lewis County. Long after the rest of the country was linked by a transcontinental railroad, visitors and supplies were brought into Old Forge on horseback or by horse-drawn buckboards. Women were often strapped to the wagons to keep them from falling off. An early guidebook described the ol' Brown's Tract Road as presenting such a forbidding appearance that it would "make a crow shed tears to fly over it."

Once in the region, early travelers and pioneer settlers used the waterways for transportation. These superhighways were connected by short carries, as seen below. Snowshoes were used on forest trails for occasional trips in or out of the Tract during the long, desolate winter months. Chapter 1 revisits the early modes of travel by horseback, buckboard wagons, canoes, guideboats, steamboats, trains, planes, and automobiles.

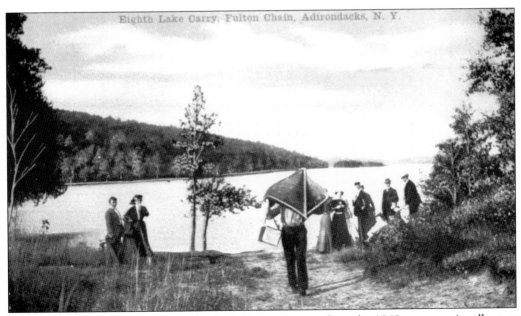

Guideboats, used for transportation in the Adirondacks as early as the 1840s, are occasionally seen on the lakes today.

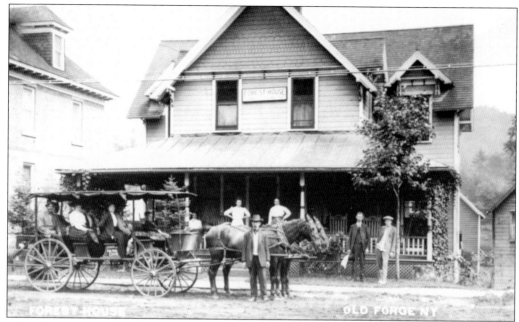

Edward "Daddy" Doolan and his wife, Mary, welcomed guests at the Forest House on Main Street for more than 40 years. Doolan's horse-drawn "taxis" met the trains at Fulton Chain and brought passengers into Old Forge for 25¢ per person. This historic building houses the Century 21 Real Estate office today.

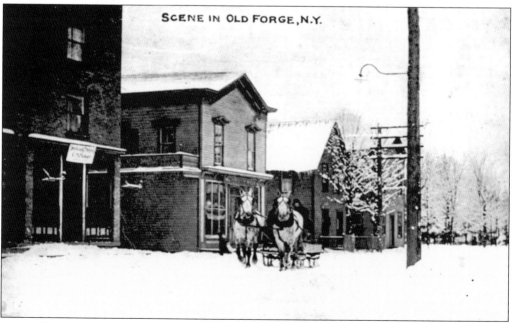

A lone horse-drawn sled glides along Main Street in Old Forge on a winter day in 1905. The Covey Building and Barker's Supply Store, in the foreground, are long gone. The third building, known today as the Artworks, once housed the first post office in town.

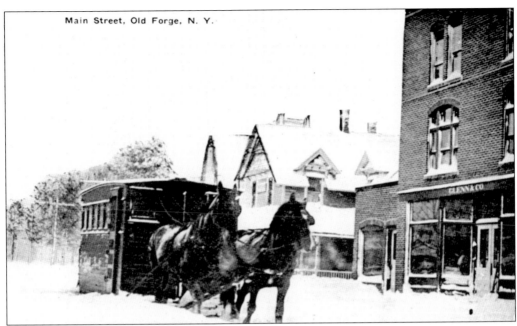

An enclosed winter taxi heads south past the Glenn & Company store, the first brick building on Main Street. The small adjacent building was the first telegraph–telephone office. The historic Glenn building also housed one of the town's first bowling alleys. Today, it is the home of Wilderness Interiors.

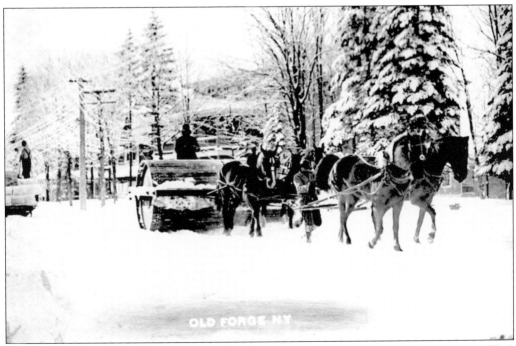

Before the advent of motorized vehicles, snow was packed down by a heavy, water-filled, horse-drawn roller.

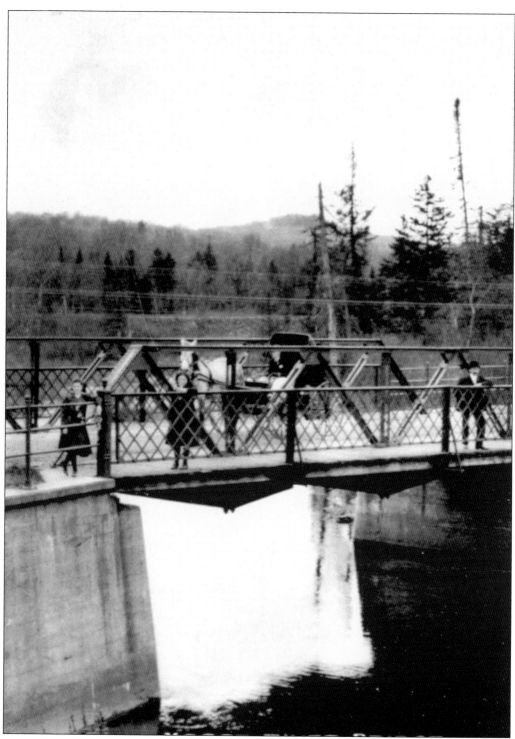

A very early bridge crosses the Moose River between Old Forge and Thendara at the same location as it does today. This is the point where the north and middle branches of the Moose River merge, and it is one of the finest views of the river.

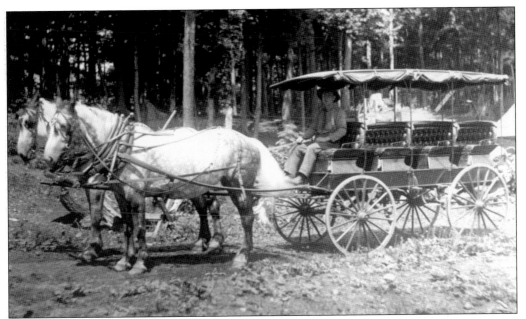

Passenger buggies were needed to transport large parties between Old Forge, Eagle Bay, and Big Moose. F. Baxter had this buggy for hire and sent postcards to prospective clients to advertise his business.

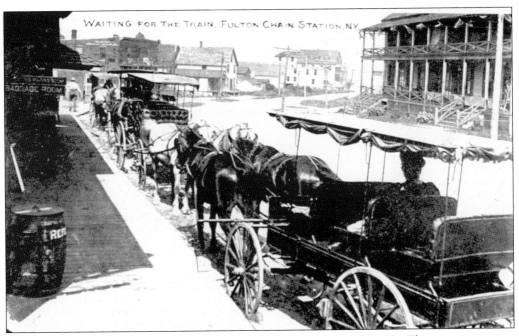

By the early 1900s, thousands of tourists were coming to the area by train. The passengers were met by horse-drawn buggies sent by the various hotels. This scene is in Fulton Chain, later renamed Thendara. The building on the right is Van Auken's Inne, which is still operating today.

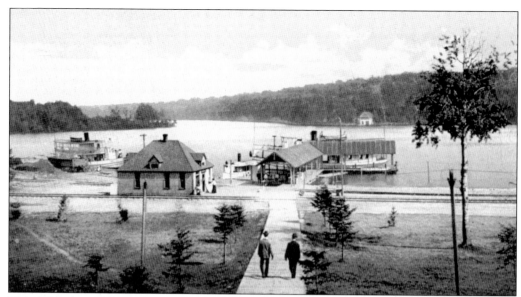

This 1904 view of the active waterfront at Old Forge Pond was taken from the Forge House. The short wooden boardwalk led hotel guests to the steamboat docks or to the station for the Fulton Chain Railroad, which was built in 1895. The railroad connected passengers to the New York Central Adirondack Line two miles south of town.

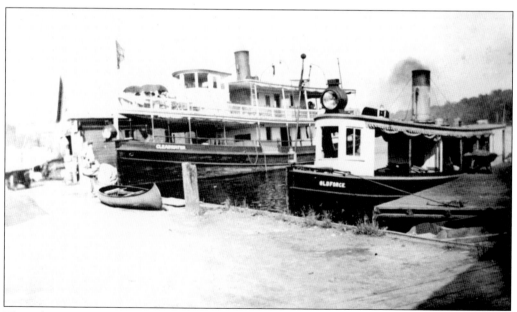

The *Clearwater,* launched in 1900, was the grandest steamboat plying the waters of the Fulton Chain. Moored alongside is the smaller passenger steam launch *Old Forge,* which was also used as a mailboat.

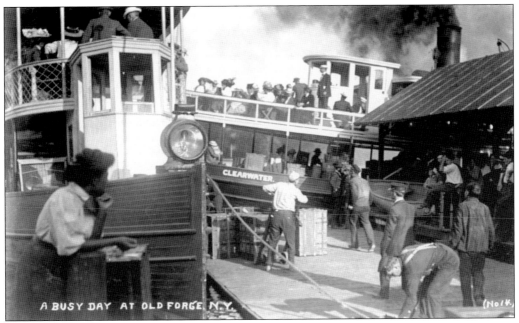

Passengers and freight were loaded onto steamboats at the busy docks at Old Forge Pond. Steamboat service continued until World War II, when metal components were salvaged for the war effort.

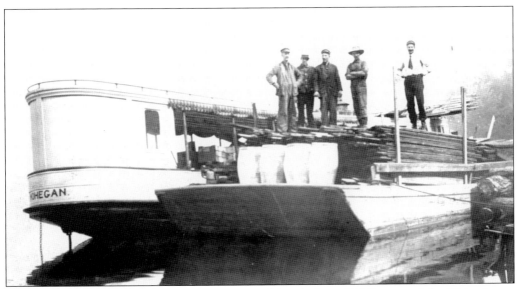

The *Mohegan* delivered supplies to the camps and hotels from Old Forge to Inlet. This picture, taken *c.* 1907, shows a load of lumber en route to the Bay View Camp. The man at the extreme left is Orley Tuttle, inventor of the Tuttle Bug fishing lures and flies, which were crafted from deer hair.

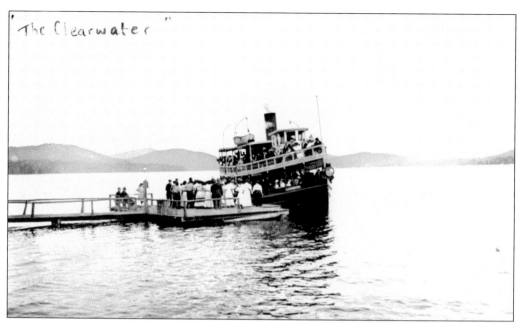

"The Clearwater"

Hotel guests at Becker's Camp on Fourth Lake prepare to board the *Clearwater*. In the 1890s, this landing was used by travelers destined for Moss, Dart's, and Big Moose Lakes. Mr. and Mrs. Fred Becker purchased the site in 1904, and the family operated a resort here until the 1970s. It is the present location of Holiday Shores Estates.

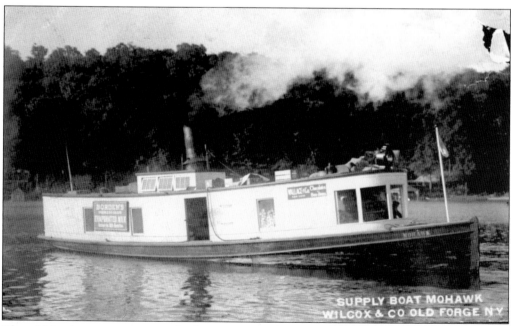

The *Mohawk*, a grocery supply boat commonly known as the Pickle Boat, stopped at docks from Old Forge to Inlet. It was operated by the Marks & Wilcox Company from 1905 to 1939.

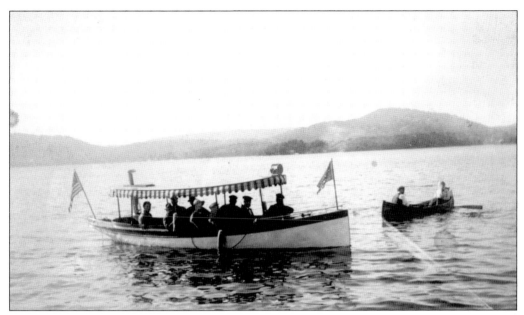

In the early 20th century, there were many experimental powerboats on the lakes. The naphtha launch, pictured here, was one such vessel. It burned a liquid form of naphtha, the same ingredient that is found in mothballs. There is still one operating naphtha launch on the Fulton Chain.

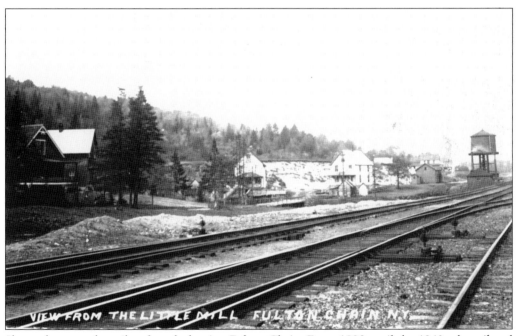

Shown here are the railroad tracks leaving Fulton Chain. From 1892 until the 1940s, the railroad was the most important transportation link to the area. Passenger service was discontinued in 1964. In 1992, a seasonal tourist train, the Adirondack Scenic Railroad, commenced service along the original historic route.

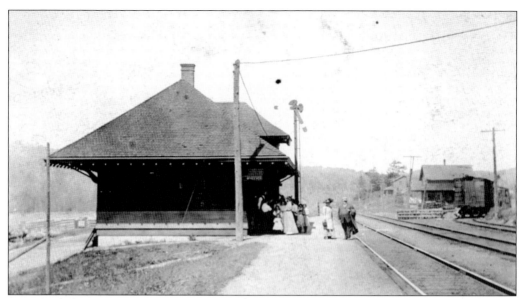

Pictured here and on the facing page are four regional train stations. Notice the architectural similarities. The above photograph features the McKeever Station, still in existence—unlike the Rondaxe Station on the Raquette Lake Railroad line, below, which has disappeared.

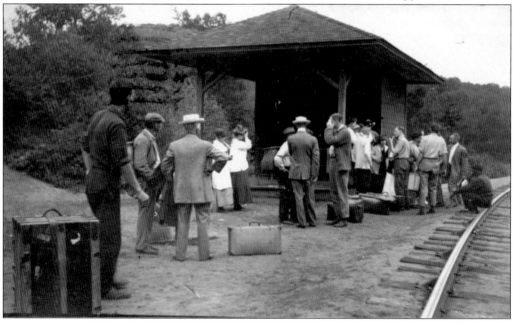

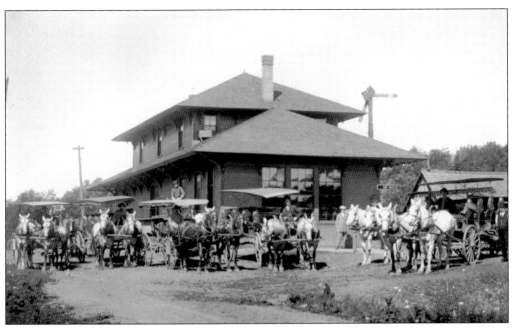

The photograph above shows the original station at Big Moose, which burned *c.* 1920. The station was immediately rebuilt and now operates as a restaurant. In the photograph below, a crowd awaits the arrival of the train at the Beaver River Station.

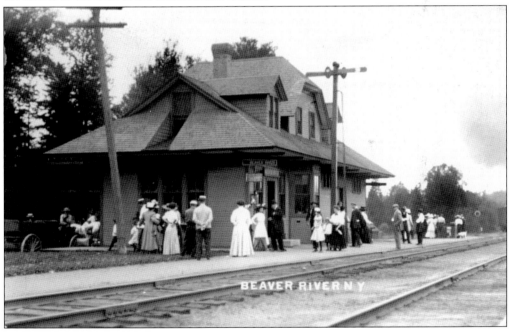

BEAVER RIVER N Y

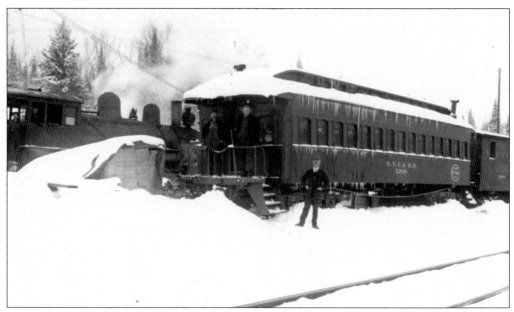

This was a temporary freight office at Brandreth Station, once a booming logging center. Brandreth Park was established in 1851 by Dr. Benjamin Brandreth. Today, the 10,000-acre park is owned by Brandreth's descendants.

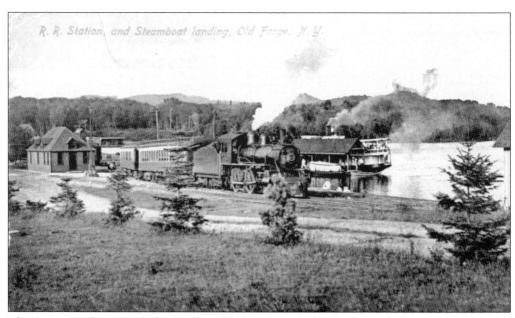

This is an excellent view of the Fulton Chain Railroad, which chugged up the spur line from Thendara to the Old Forge waterfront. It was built in 1895 and operated into the 1930s. The station was located adjacent to the municipal beach and tennis courts.

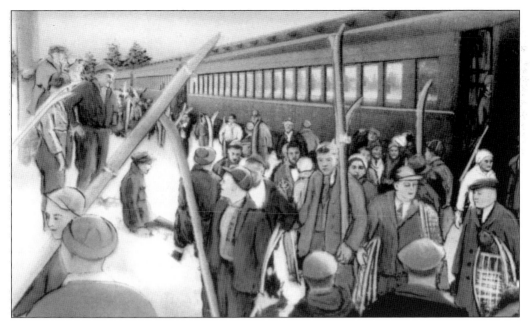

Beginning in the 1930s, snow trains brought winter sports enthusiasts into the region from New York City and central and western New York State. Passengers were met at the Thendara station and transported to the heart of Old Forge for skiing at Maple Ridge, tobogganing, ice-skating, and other winter sports activities.

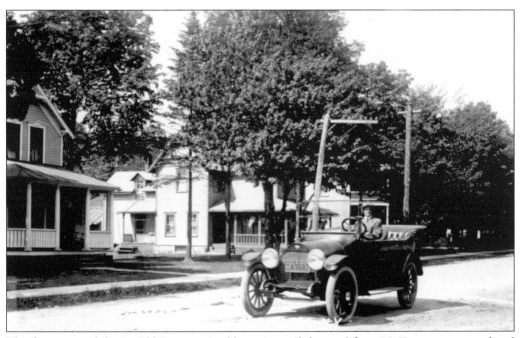

The first automobiles in Old Forge arrived by train until the road from McKeever was completed in 1916. Earl Glenn, pictured here, is driving a 1915-licensed car past comfortable homes on Adams Street in Old Forge. Adams Street remains much the same today.

Quiver Pond is located halfway along the South Shore Road between Old Forge and Inlet. Although there are many camps along this section of the Fulton Chain, few are visible from the roadway.

The roadway in this early photograph of Route 28 alongside Fifth Lake just north of Inlet was a challenging ride for both drivers and passengers. The route was finally paved in the late 1920s.

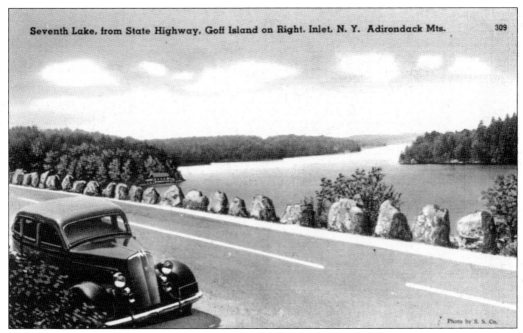

Photo by S. S. Co.

The view from the Seventh Lake overlook has changed little since this photograph was taken in the 1940s. This is truly one of the prettiest vistas in the area.

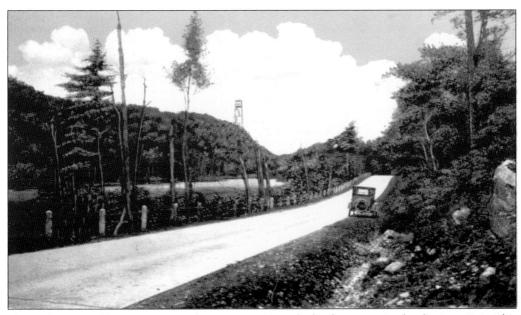

Shown here is Bald Mountain Pond, on Route 28, with the fire tower in the distance. From this location the tower is actually not visible. Two negatives were combined to create the image. This was a common practice in the production of early postcards.

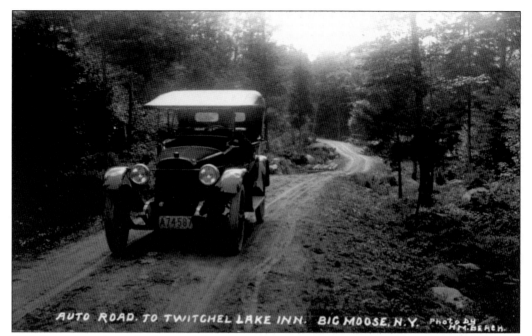

AUTO ROAD. TO TWITCHEL LAKE INN. BIG MOOSE, N.Y. Photo by H.M. BEACH.

Earl Covey carved out the first road from Big Moose Station to his hotel on Twitchell Lake in the 1890s. He and his father, Henry Covey, were two of the first guides and builders in the Big Moose region. This card, mailed in 1919, was sent by Earl to G. Harry Brown in Old Forge.

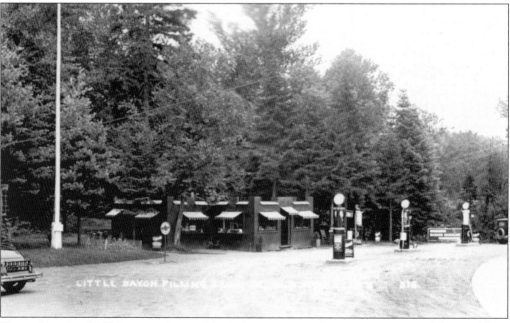

LITTLE BAYOU FILLING

Situated north of Old Forge on Route 28, Little Bayou served as a gas station, snack bar, and boat livery until the mid-1960s.

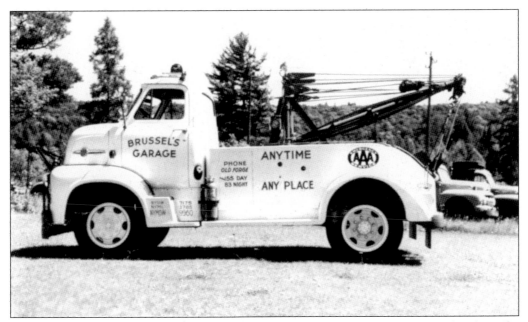

For many years the Brussel family operated a garage, towing, and bus service in Thendara. The slogan on the truck says it all.

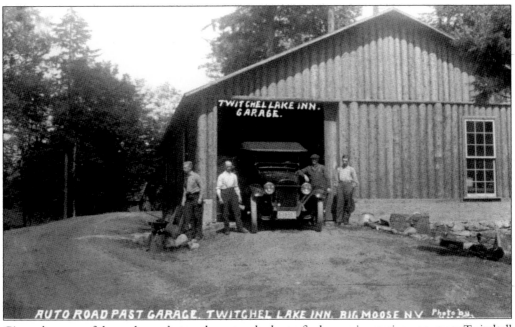

Given the state of the early roads, travelers were lucky to find a service station at remote Twitchell Lake. Owner Earl Covey, second from the left, was assisted by his son Sumner Covey, far right, at the Twitchell Lake Inn Garage.

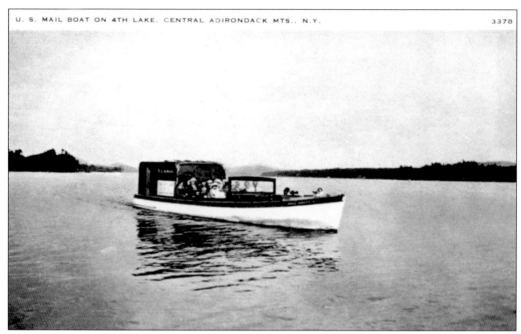

Mail delivery by boat began *c.* 1896 when former Pres. Benjamin Harrison requested daily delivery to his camp on Second Lake. This was the first known place in the United States to have mail delivered in this fashion. Mailboat service is still available to lakeside camp owners.

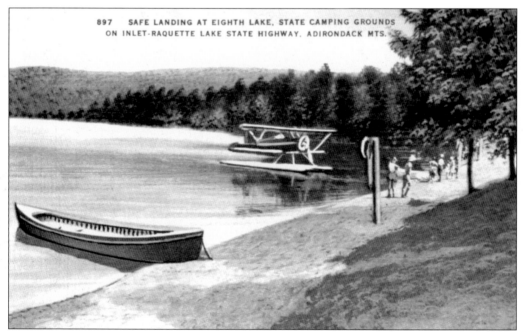

897 SAFE LANDING AT EIGHTH LAKE, STATE CAMPING GROUNDS ON INLET-RAQUETTE LAKE STATE HIGHWAY, ADIRONDACK MTS.

Seaplanes have been a popular way to go sightseeing in the Adirondacks since the 1930s. They have also been used to transport campers and supplies to remote lakes, to spot fires, and to conduct search and rescue missions.

Two

HUNTING, FISHING, GUIDES, AND WILDLIFE

Well-traveled, highly educated sportsmen came to Old Forge and sought the services of local guides, as illustrated in the photograph below. Notable visitors included four presidents, Benjamin Harrison, Theodore Roosevelt, Calvin Coolidge, and Warren G. Harding, as well as other nationally known dignitaries. Guides built the first permanent homes in Old Forge. By the end of the 19th century, habitat and wildlife were declining at an alarming pace. In 1898, with their livelihood at risk, local woodsmen formed the Brown's Tract Guide Association. Over the next decade, the association successfully fought for legislation to outlaw hounding (hunting with dogs) and deer jacking (hunting from boats at night with lamps) and convinced state officials to shorten the hunting and fishing seasons.

This chapter pays tribute to the legendary Adirondack guides of the region who had the courage and survival skills needed to carve out a settlement deep in the wilderness. Many Old Forge residents today are proud descendants of these intrepid pioneers. Nature has renewed the heavily logged forests, and once again, wildlife sightings occur frequently.

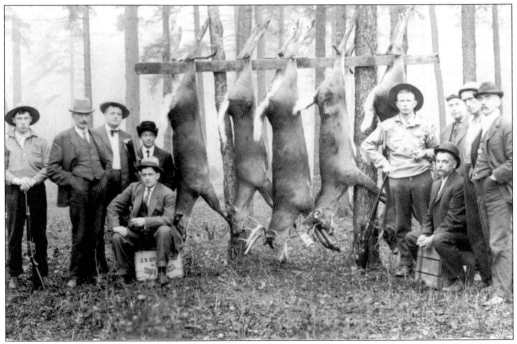

Adirondack guides pose with their clients, referred to as sports, following a successful day of hunting.

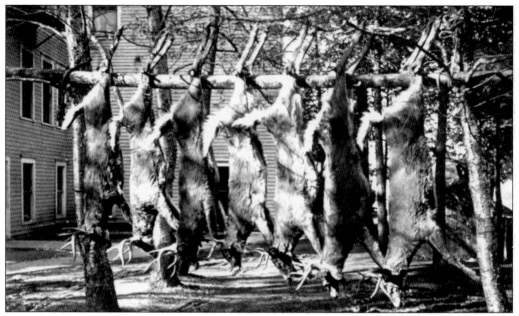

An independent guide provided boat transportation for his clients, portaged supplies, built primitive shelters, cooked all the food, and knew where to find game or the best fishing holes. Hotels such as this one employed numerous guides for sportsmen less inclined to rough it in the North Woods.

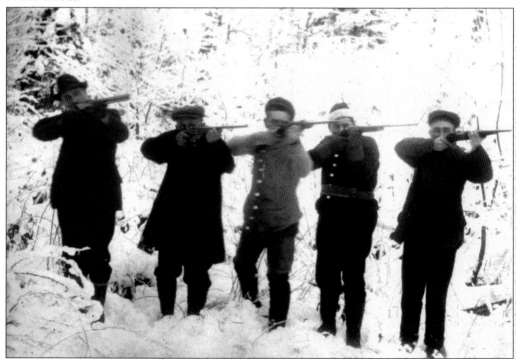

Five hunting companions pose for a photographer on a winter day in the North Woods. Scores of hotel guests returned year after year; some formed hunting clubs or bought property in the area, later enjoyed by successive generations of family members.

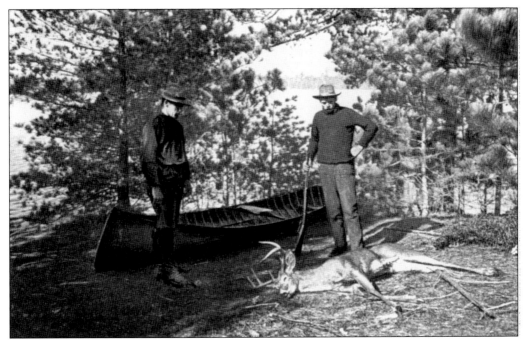

A skillful, dependable guide was highly regarded, and his reputation spread far beyond the boundary of the Adirondack Park. Murray's 1869 guidebook, *Adventures in the Wilderness*, described the Adirondack guide as modest in demeanor and speech, honest to a proverb, and fearless of danger.

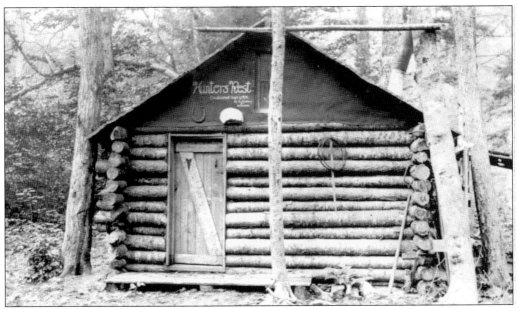

Hunter's Rest, established by guides E. Risley and W. Parsons, was privately owned and built in 1914 near Seventh Lake. Before the creation of the Adirondack Park in 1892, local woodsmen roamed freely over trails and erected shelters or cabins for their clients on private or state land.

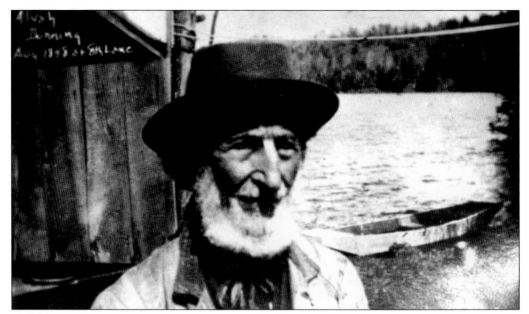

Alvah Dunning, a legendary trapper, guide, and woodsman, was sometimes called the meanest man in the Adirondacks. According to legend, he killed a moose when he was 12 years old. Dunning fled into the woods in 1865 after severely wounding his unfaithful wife. He lived in squatter's camps most of his life and had a primal hatred of newcomers. Dunning was so well known that his 1902 obituary was carried in newspapers all over the country.

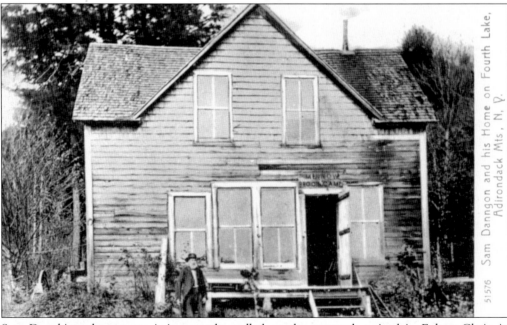

Sam Dunakin, whose name is incorrectly spelled on the postcard, arrived in Fulton Chain in 1849. He took time out to serve as a sharpshooter in the Civil War. When he returned he spent the next 36 years guiding sportsmen and building camps in and around the Fulton Chain of Lakes. Dunakin's own camp, pictured in the photograph, was built in 1871 on the north shore of Fourth Lake.

Sam Dunakin was a resourceful individual, as were all Adirondack guides. In 1876, he took in his ailing niece, who unfortunately died four months later. As heavy snowfalls made the Brown's Tract Road impassable, Dunakin stored the body in his icehouse until the weather abated weeks later and he could sled it to Boonville for funeral arrangements.

Twinkle-eyed Chris Goodsell, like many Adirondack guides, was also a builder and operated a hotel on Fourth Lake called the Ramona. One of the structures he built was St. Peter's Church on Fourth Lake. Goodsell's nephew Bob Goodsell bequeathed the family's Old Forge Main Street home to the Town of Webb Historical Association.

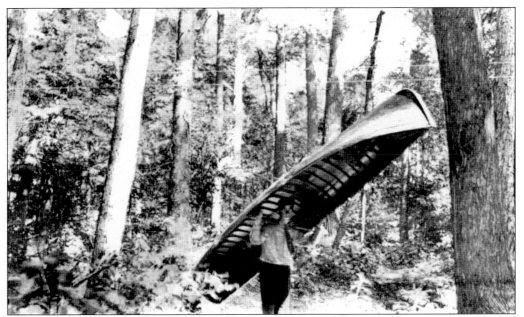

Lightweight guideboats weighed 65 pounds on average. The ribs were made from spruce root crooks, taking advantage of the natural curve in the grain. The thin planking kept the weight down, allowing guides to easily shoulder them over carries.

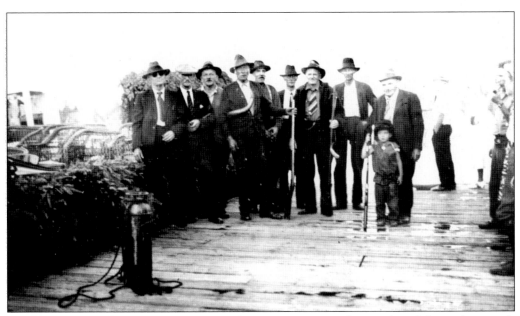

In 1932, the last of the Brown's Tract Guides Association members gathered for a photograph on the docks at Old Forge Pond. Pictured from left to right are P.G. Rivett, W. Sperry, W. Weedmark, E. Marks, C. Puffer, B. Parsons, D. Fraula, I. Parsons, and D. Charbonneau. The boy in the foreground is Keith Hollister.

Humorous postcards are still popular with vacationers in the Old Forge region. This exaggerated "wish you were here" penny postcard was sent home to a fisherman father in the Syracuse area in 1933.

A FAMILIAR SCENE IN THE ADIRONDACK MOUNTAINS 202

3832

A few highly competent women guides worked on the Fulton Chain of Lakes. Lottie Tuttle and her daughter Edie were among the best and also helped make the Tuttle Bug fishing lures that were sold nationwide. Women visitors were often active participants in sports outings, as illustrated in this postcard.

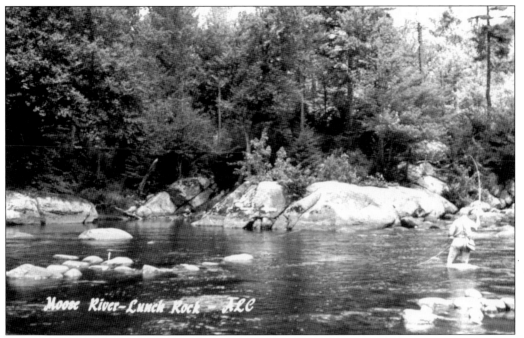

A group of influential sportsmen formed the Adirondack League Club (ALC) in 1890. This fisherman is enjoying an outing on the south branch of the Moose River, which flows through the ALC's private preserve.

Adirondack lakes and ponds host fishermen in both summer and winter. After arriving on snowshoes, anglers here have opened a hole in the ice in order to fish. Some ice fishermen build shanties on the lakes for shelter.

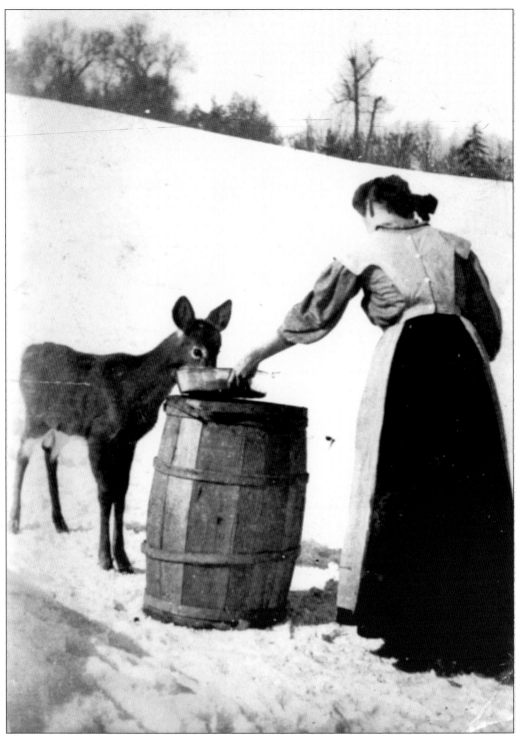

Salt licks to lure deer were outlawed by New York State in the early 1900s. Feeding deer has always been popular, but it is detrimental to the health of the animal and also brings them in perilous contact with automobiles on today's roadways.

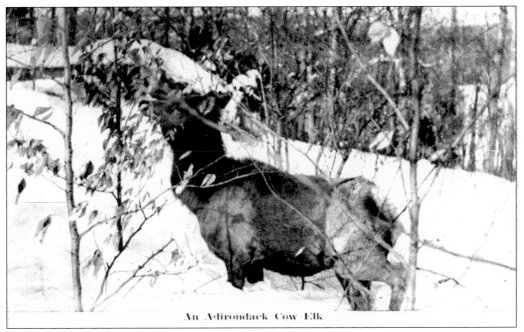

An Adirondack Cow Elk

This is a rare photograph of an Adirondack elk. At the end of the 19th century, several attempts were made to introduce elk into the region. Some controversy exists as to whether elk were at one time native to the Adirondacks, but none are known to exist here today.

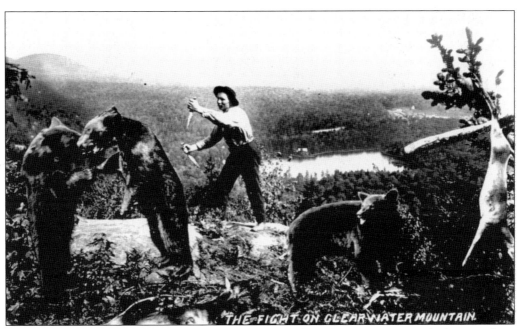

THE FIGHT ON CLEAR WATER MOUNTAIN.

Henry Beach was one of the region's most prolific early-20th-century postcard photographers. Beach humorously manipulated this photograph to exaggerate the prowess and courage of an Adirondack guide.

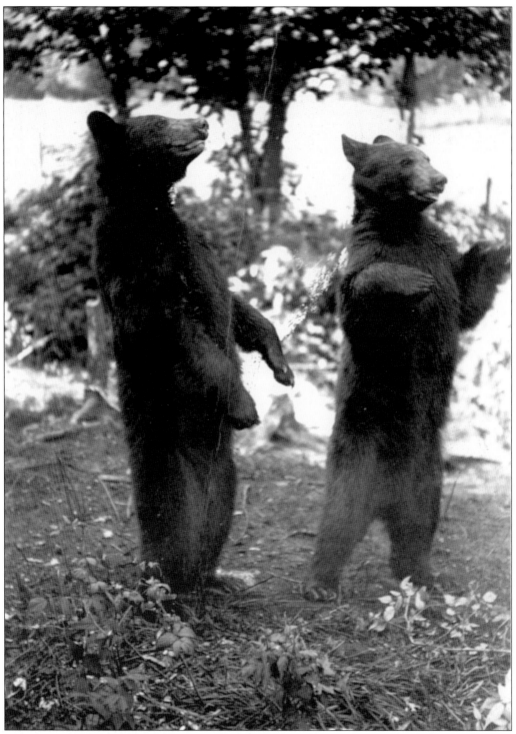

Folks have always been fascinated by bears. These yearlings appear to be striking a pose for postcard photographer Henry Beach. The Adirondack black bear is not generally aggressive but can be provoked to attack.

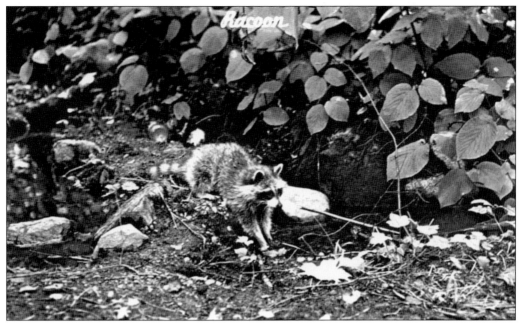

Another charming but mischievous resident is the raccoon. These masked bandits are nocturnal by nature and are adept at stealing food.

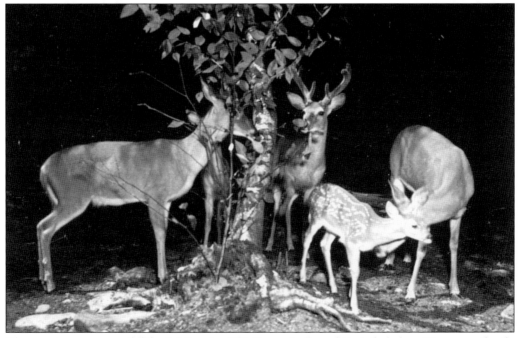

The most common wildlife sighting in Old Forge is the white-tailed deer. To spot a family grouping such as this is quite rare.

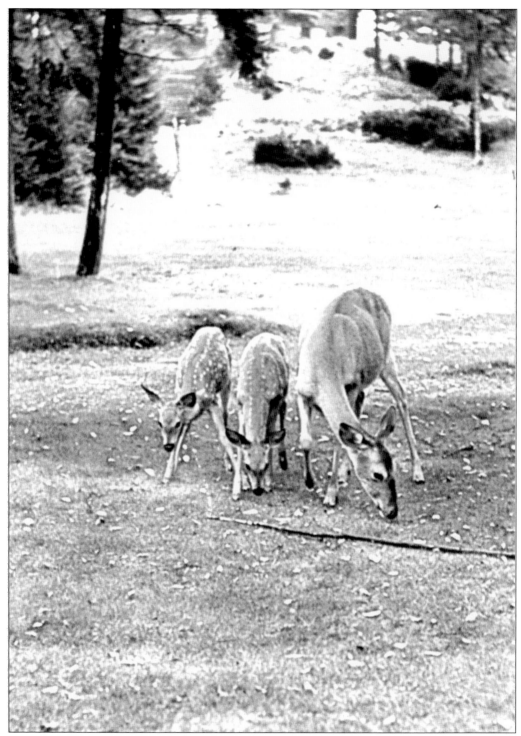

Spotted fawns are easy to find in June and July. Twins are not uncommon. Lack of predators has led to an overpopulation of white-tailed deer throughout the country and here in the Old Forge region as well. Nevertheless, deer continue to delight amateur photographers and visitors.

Three

LOGGING AND OTHER INDUSTRIES

Deep in the woods today, it is not uncommon to come upon an old clearing that was once a bustling logging camp or the ghostly remnants of former logging communities such as Moulin, Carter, Brandreth Station, Woods Lake, or the Moose River Settlement. Thousands of immigrant loggers, teamsters, jobbers, and road monkeys (men hired to sand the icy logging roads) swarmed through the woods cutting the mighty primeval forests and transporting the logs to the Moose, Independence, or Beaver Rivers. In the springtime the logs began the tumultuous descent down the river to the mills at Fulton Chain, McKeever, Lyonsdale, Lyons Falls, and Port Leyden. Logs were turned into French heels, piano sounding boards and violins, wooden spoons and bowls, plywood veneers, and paper. Many were harvested to provide materials for the early-20th-century construction boom in the Old Forge region or to fuel the steamboats chugging up the lakes.

At various times there were prosperous sawmills along the middle branch of the Moose River at McKeever, Fulton Chain, Old Forge, Third Lake, and Inlet. Logging also flourished to the north in the Big Moose-Beaver River and Stillwater region. Other than tourism, logging and related activities provided far more employment opportunities than all other industries combined.

This stylized postcard romanticized the hard life loggers endured in a winter lumber camp.

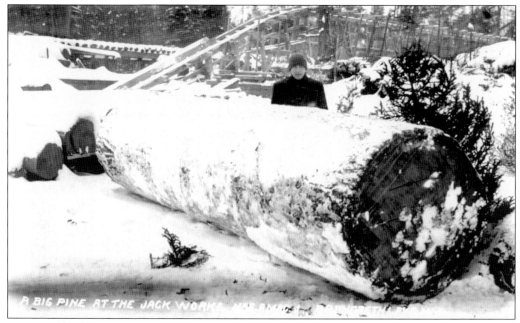

A BIG PINE AT THE JACK WORKS

The virgin timberland of the Adirondacks was a logger's paradise, and great tracts remained uncut well into the 20th century. Logging operations at Brandreth Park began in 1912. The Mac-A-Mac Corporation built a railroad spur from the Adirondack Division of the New York Central Railroad to Brandreth Lake in order to haul out these giant logs.

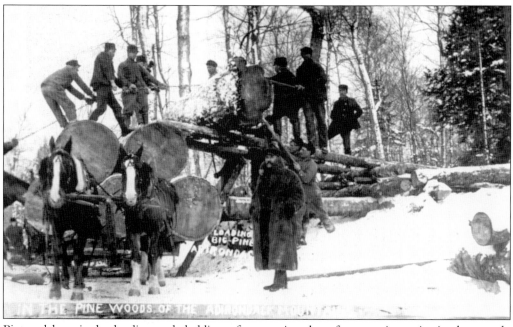

LOADING BIG PINE ADIRONDA...

IN THE PINE WOODS OF THE ADIRONDA...

Pictured here is the loading and sledding of more giant logs from a winter site in the woods. Softwoods were drawn to river landings and floated to the nearest mill. Logs were generally cut into 13-foot lengths, known as the Adirondack standard.

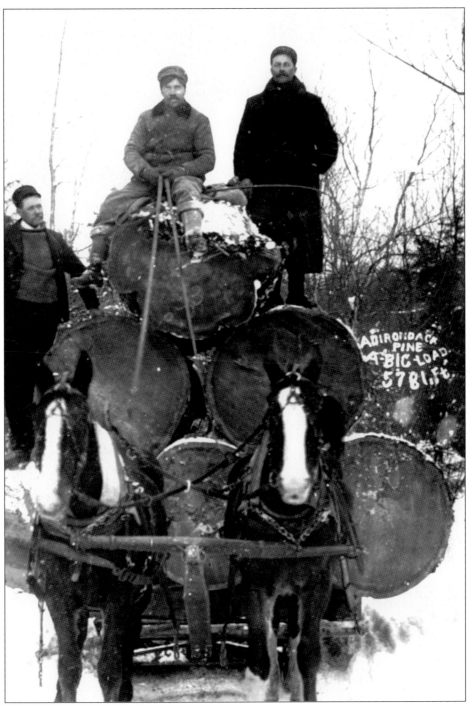

Driving the skidway in this photograph is Big Moose teamster Vic McPhee, a hard-drinking, mean-tempered Scotsman who hailed from Old Town, Maine. The lumber camps attracted a wide assortment of rugged individuals, and McPhee was among the most notorious in the Big Moose region. He narrowly escaped a manslaughter charge after killing a local man in a barroom fight. McPhee was later convicted of armed robbery and rape charges in Herkimer.

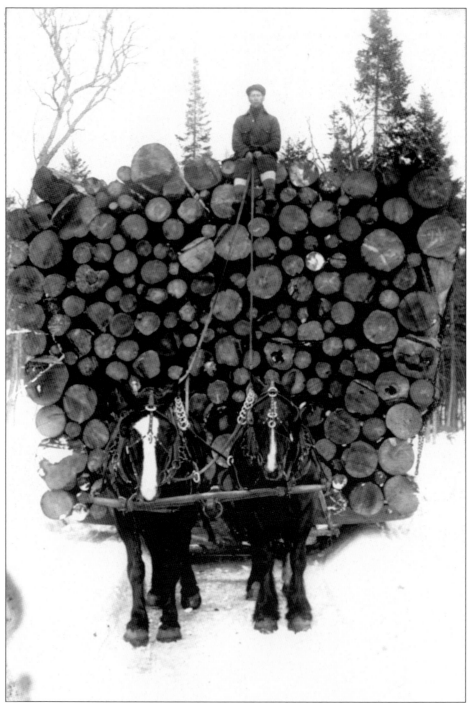

A good hauling team was highly valued by its owner, but many crippling accidents occurred, sometimes resulting in the death of both horses and men. Logging companies hired road monkeys to water or sand the icy logging roads in order to keep the heavily loaded sleds from plummeting out of control. This photograph was sent in 1914 from Clearwater, later renamed Carter Station, once a bustling logging community northwest of Old Forge.

The logs above are stacked and waiting to be transported to a river drive. Most cutting and transporting of logs was done during the winter because it was easier to haul them over snow-covered trails than across muddy roads during the spring and summer. The postcard below is unusual since women were rarely present in the lumber camps. A few were hired as cooks or served as camp prostitutes.

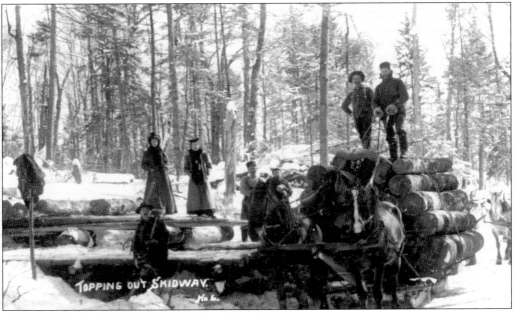

TOPPING OUT SKIDWAY.

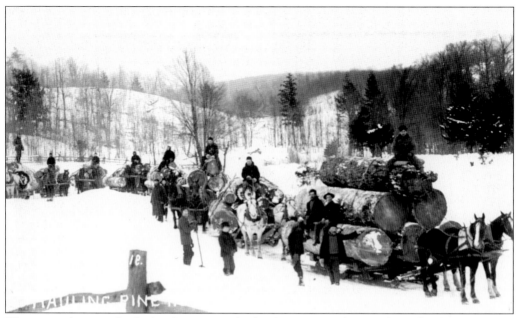

These two photographs depict alternate methods of moving cut logs to the mills. The spectacular horse-drawn caravan of sleds was most likely headed for a river drive. In the 1920s, many horse teams were replaced by Lynn tractors. Lumber camps near train tracks loaded logs onto flatbed cars for transport directly to the mills.

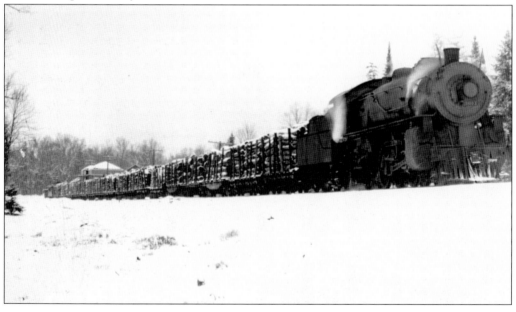

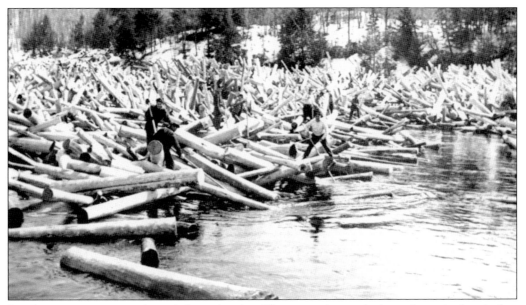

Log jams were a constant hazard along the river. The men who worked to release the logs had to be agile and accustomed to working in frigid weather. This was truly treacherous work.

Logging camps were frequently miles from villages and were bustling communities unto themselves. Lumberjacks had to live there for months at a time. Many were bachelor immigrants. The work was repetitive and dangerous, even life-threatening. A skillful lumberjack was highly regarded by his peers.

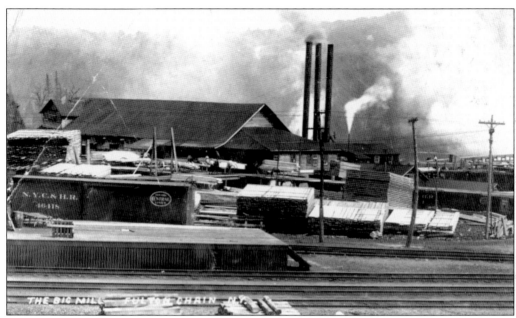

George Deis's first mill was at the Old Forge Dam. In 1900, Deis built this large, modern mill in Fulton Chain. Because of its strategic location on the Moose River, logs could be floated directly to the mill, processed, and loaded onto railroad cars. Of the three mills located at one time in Fulton Chain, the Deis mill was the only one to survive the labor shortages of World War I.

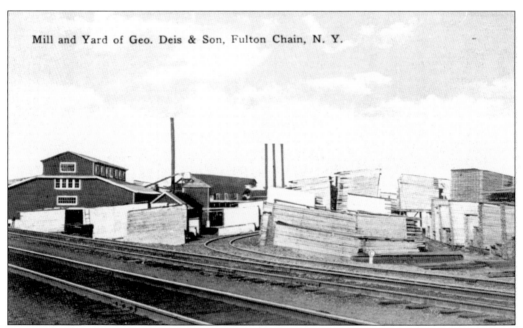

The Deis mill manufactured finished goods such as doors, windows, porch and stair rails, and decorative moldings, which are found in many Old Forge homes today. Several of the century-old Deis lumbermill buildings can still be seen along the shoreline of the Moose River as it meanders through Thendara.

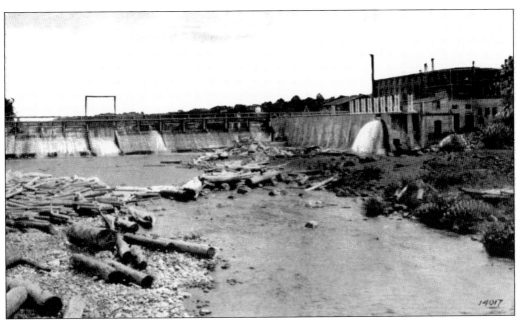

The original dam and sawmills at McKeever were built by former governor John Dix at the beginning of the 20th century. By the 1920s, the Gould family of Lyon's Falls had purchased the mill and greatly expanded operations. A 1947 spring flood tore out the dam, which was never replaced. The mill ruins are still visible from the bridge on Route 28 near the hamlet of McKeever.

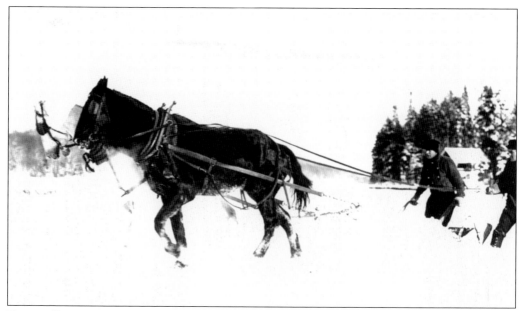

Teams of horses were used on Old Forge Pond in the ice-cutting industry. The photograph above depicts the first process: scraping snow from the ice. In the photograph below, horses are pulling ice cutters. The harvested ice blocks were packed in sawdust and stored for summer use or loaded into railroad boxcars for transport. This industry provided much needed employment throughout the region during the long, harsh winter months.

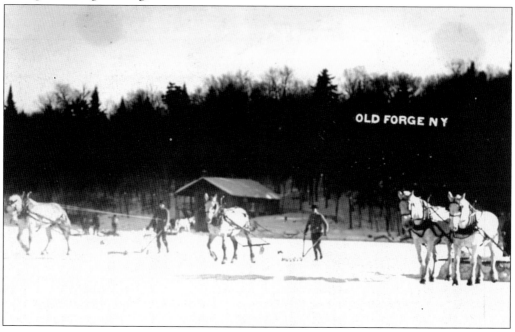

The Tennis brothers and Ginther family operated the Fulton Chain Bottling Works early in the 20th century. This company manufactured soda pop, bottled water, birch beer, and other beverages. The glass bottles are occasionally unearthed today and are highly collectible. Today, the Bottling Works building is a private Thendara residence and looks much the same as it did 100 years ago.

The state of New York employed local men to manage this fish hatchery, located just below the dam at Old Forge Pond. Each year thousands of fingerlings were released into the lakes and streams to restock fish depleted by anglers. This historic building has since served as a hay fever club, town hall, local jail, and police station; it is now the home of the Covey-Pashley Chapter of the American Legion.

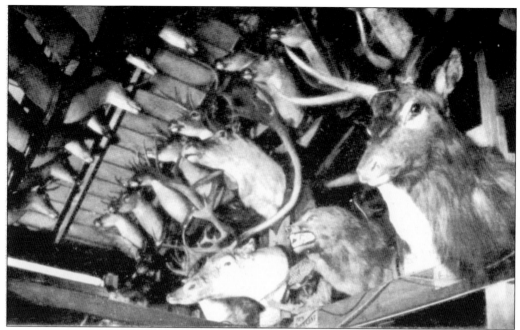

Taxidermy was another unusual small industry in the Old Forge area. For many years Artemus M. Church operated a taxidermy studio near the Busy Corner on Main Street. Some of these vintage trophies still adorn the walls of older camps.

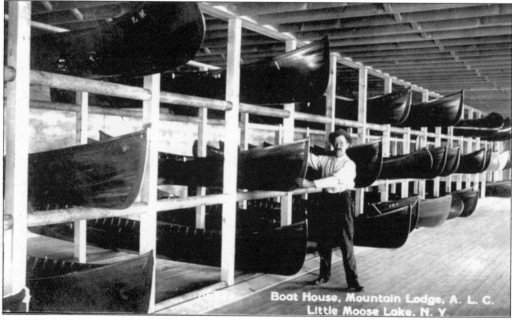

Boat House, Mountain Lodge, A. L. C.
Little Moose Lake, N. Y.

Building guideboats was a unique Adirondack industry. Many in this photograph were built in Old Forge by master boatbuilders Riley, Ira, and Ben Parsons. A hand-crafted guideboat, a cross between a canoe and a rowboat, had exceptional strength. The Parson family produced approximately 30 guideboats a year. Each guideboat sold for $600 to $800. Those that have survived are highly desired by collectors today.

Four

COMMUNITY LIFE

At the beginning of the 20th century, nearly 200 people resided in the fledgling hamlet of Old Forge. With dependable rail transportation into the community for nearly a decade, the pioneer families responded to a period of rapid growth and prosperity. Permanent homes, built on top of hand-dug stone foundations, replaced seasonal cottages. The Forge House Hotel, in the center of the photograph below, dominated the waterfront and downtown landscape. New commercial buildings connected by wooden boardwalks soon stretched up Main Street.

Undaunted by the unpredictability of the harsh Adirondack climate and a tenuous economy, the local citizenry invested in the future of their community. They built churches and formed fraternal and civic organizations. Public servants were elected to organize a school and manage municipal tasks that included water and sewer service, street lighting, garbage and snow removal, and the appointment of a health officer. Neighbors depended upon neighbors, and the generous spirit of lending a hand to someone in need that prevailed in the early years of the hamlet's development is a characteristic that has survived to this day.

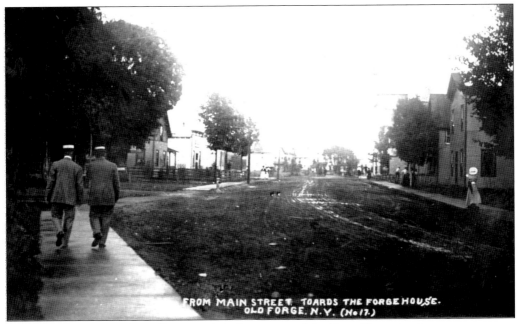

FROM MAIN STREET TOARDS THE FORGE HOUSE.
OLD FORGE. N.Y. (No.17.)

Wooden sidewalks made strolling on Main Street toward the Busy Corner a pleasure.

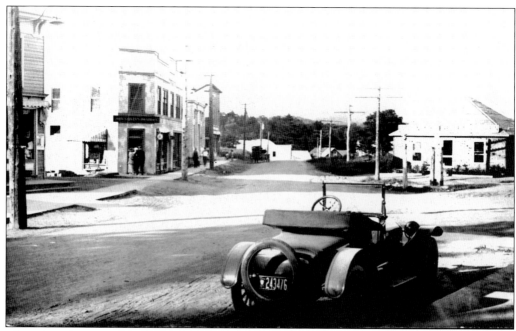

The 1917 photograph of the Busy Corner in Old Forge shows the Adirondack Development Corporation's real estate office. William Thistlethwaite, president, claimed he filed over 3,000 deeds at the Herkimer County Tax Office for lots sold in the township. In the card below, *c.* 1923, the Texaco gas station has replaced the real estate office at the Point. Across the street are the Given Building, which housed the local pharmacy until 2001, the First National Bank of Old Forge, and Hurley & Ryan's Supply Store.

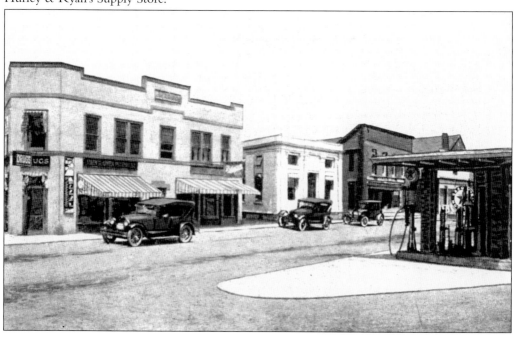

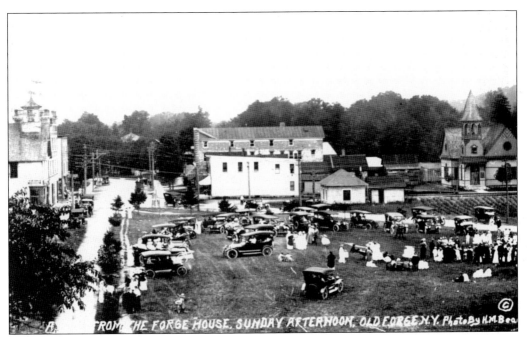

Old Forge band concerts have always drawn crowds, as shown in the photograph above. The original Presbyterian church, on Crosby Boulevard across the street from the Forge House vegetable garden, is at the far right. Left of the church is the Berkowitz Store, with the Lenhardt Bakery behind it. The crowd has grown in the photograph below. The buildings in the background are, from left to right, the Masonic Temple, the first wooden schoolhouse relocated to this site in 1907, the original Old Forge Hardware, and the Covey Building.

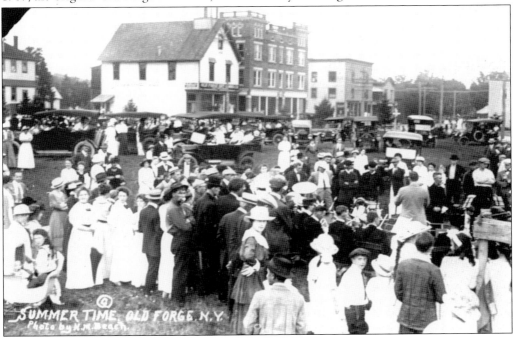

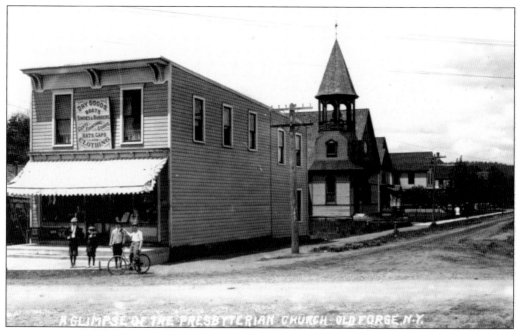

In 1888, Dr. Alexander H. Crosby and his partner Samuel F. Garmon purchased 2,000 acres of land in the heart of Old Forge. These pioneer land developers laid out the first streets in the hamlet. The Berkowitz family operated a dry goods store on the corner of Main Street and Crosby Boulevard for many decades. Behind the store is the original Presbyterian church.

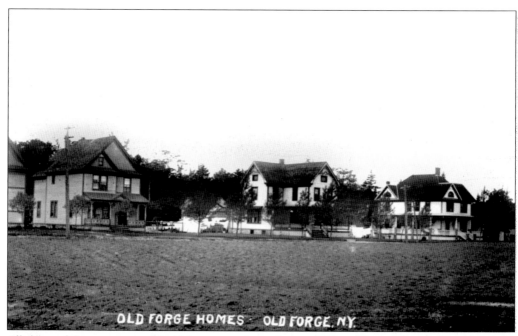

All three of these century-old residences survive today on fashionable Crosby Boulevard. On the left is the former Presbyterian manse, adjacent to banker-steamboat mogul Maurice Callahan's home. Pickle Boat co-owner Walter Marks resided in the elegant Victorian home on the right.

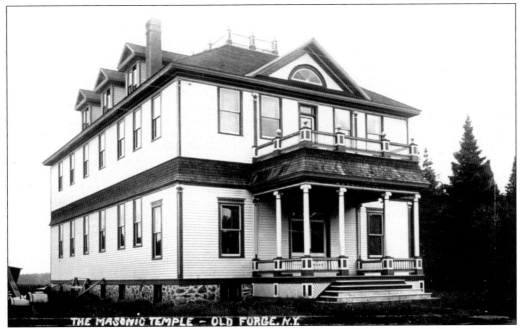

The Masonic Temple was built in 1904 on Crosby Boulevard. At various times this historic building has served the community as a temporary schoolhouse, the village municipal building, a bowling alley, a social hall, and even a dance studio. The stately structure has undergone many face-lifts but remains in use today.

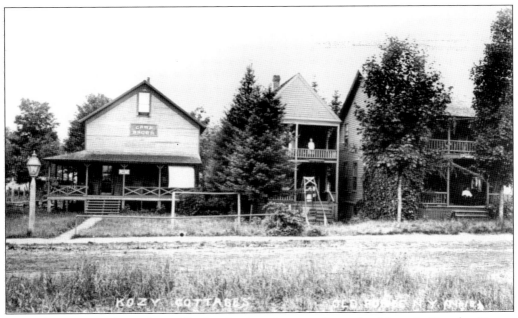

Camp Brown was located on Crosby Boulevard across from the Masonic Temple. Owner G. Harry Brown was a local entrepreneur who also owned a taxi service and served as proprietor of the Strand Theater.

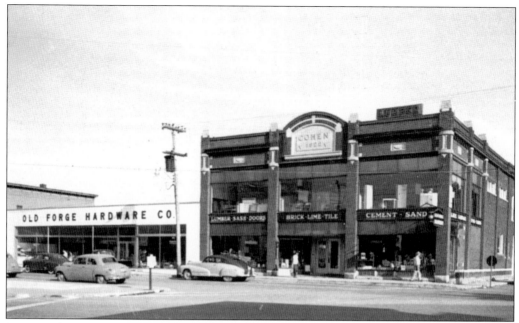

Moses Cohen opened the Old Forge Hardware at this location in 1900. The original three-story building burned in 1922 but was immediately rebuilt, as pictured here. For more than 100 years, this landmark establishment has been operated by the Cohen family.

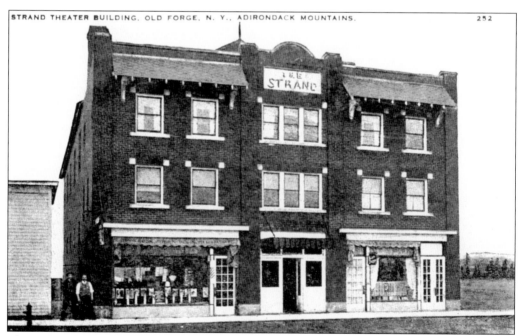

The Strand building was erected in 1922 by the Thompson family to house retail businesses, apartments, and a silent movie theater. Movies were shown sporadically from the 1950s through the 1980s. In 1992, the building was purchased by Robert Card and Helen Zyma, who have lovingly restored the theater to its former glory.

These Codling Street houses near the Old Forge waterfront were among the first permanent dwellings built in the hamlet. The home on the left was erected by guideboat builder Theodore Seeber. The Joseph Harvey residence, next door, now houses the Adirondack Bank. The two remaining buildings, including the Codling family home, were demolished in the 1980s to make room for McDonald's.

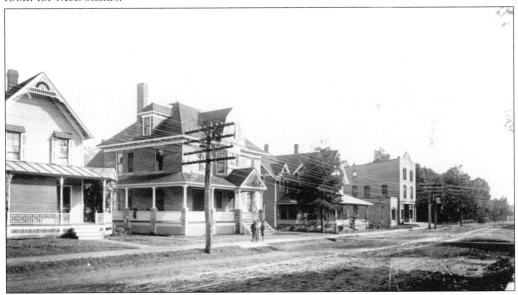

This section of Main Street, known in the late 1890s as Harrison Avenue, has seen very few changes during the last century. The gracious home in the center of the photograph was built for Dr. Stuart Nelson, who practiced medicine in the community for more than 70 years. At one time Nelson owned the small Victorian building next door, known locally as the Birthing House, where expectant mothers resided during the last weeks of their confinement.

Main Street was a muddy thoroughfare when Adirondack guide Peter Rivett built his family the home shown on the right side of this photograph. The children are standing in front of the schoolhouse, just out of view. The residence on the left behind the women with the baby stroller belonged to local blacksmith Thomas Wallace and is the present location of Gallery North.

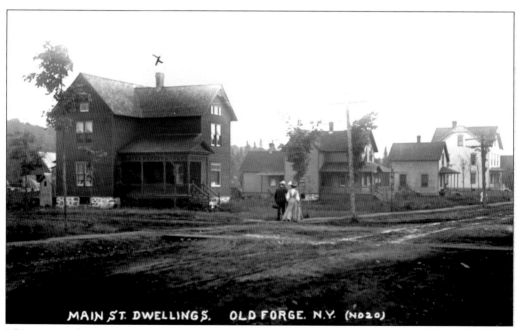

This group of residential homes is located on Main Street in the block south of the school. The Burdick home in the foreground was demolished to make way for the new Old Forge Post Office. The three adjacent residences in the photograph remain largely unchanged.

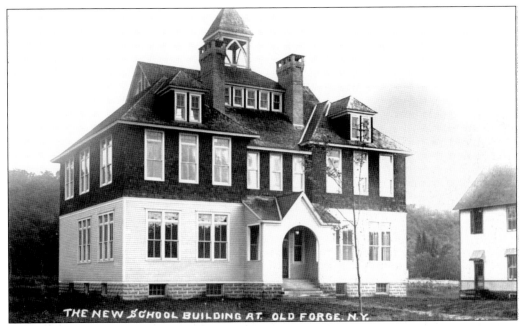

The three R's were first taught in Old Forge in 1893 in an old shed near the dam. A two-story wooden structure was built on the corner of Main and Gilbert Streets in 1895 and was replaced by this larger schoolhouse in 1907. Nearly 100 students were enrolled in classes at the time. Moses Cohen later moved the two-story building, just visible to the right, next to his Old Forge Hardware Store on the Busy Corner.

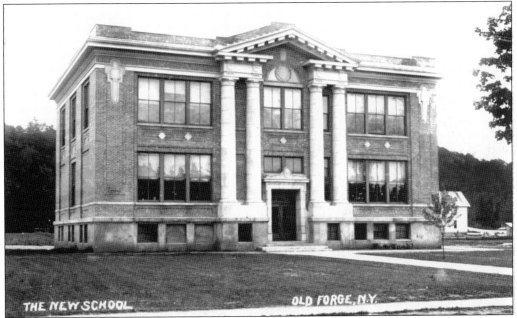

On a wintry night in March 1912, fire destroyed the 1907 schoolhouse and nearly all of its contents. A classical-style brick schoolhouse was built on the same location and is the core of the school Webb students attend today. Three seniors graduated in the first class in 1913. Thirty-six students graduated in the Class of 2002.

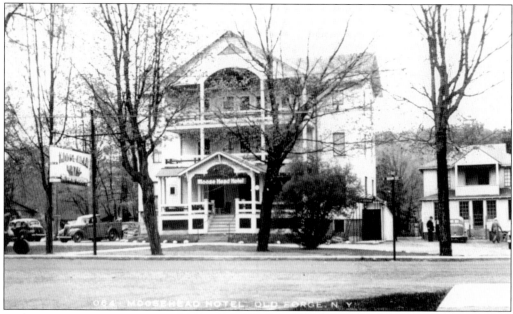

In the 1920s and 1930s, the New Moosehead Hotel provided room and board for most of the single Town of Webb teachers. Until the 1940s, school policy prohibited women teachers from marrying. The hotel now houses the Foley Hardware Store.

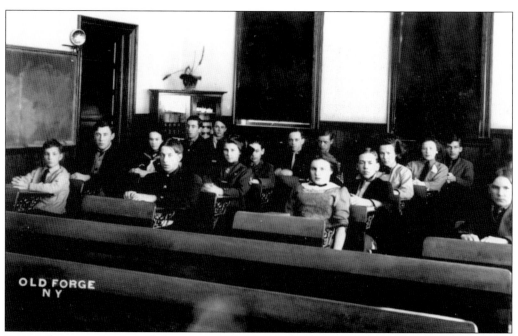

Fewer than one quarter of the 17 well-behaved students pictured in this 1910 photograph finished high school. Most of the first-generation children worked alongside of and were destined to follow in their parents' footsteps, working in local businesses or occupations.

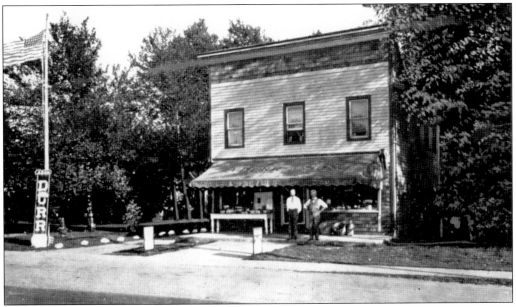

Do you recognize what is now George's Thing? Adam Durr once operated a small grocery in this building on lower Main Street. In the 1940s, the store was purchased by George Sponable, whose family has expanded the business to include a liquor, gift, and flower shop.

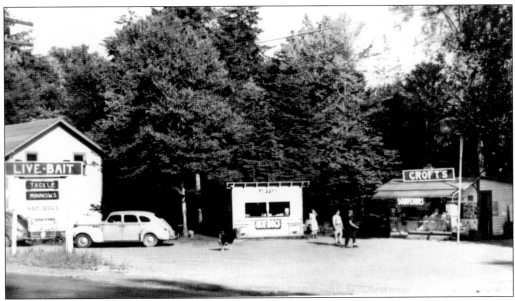

Croft's bait and souvenir stand was everyone's favorite place. The proprietor, Basil "Croftie" Croft, had a curmudgeonly personality but was loved by children and adults alike. This unique establishment was located across from Mr. Apple's Farm Restaurant.

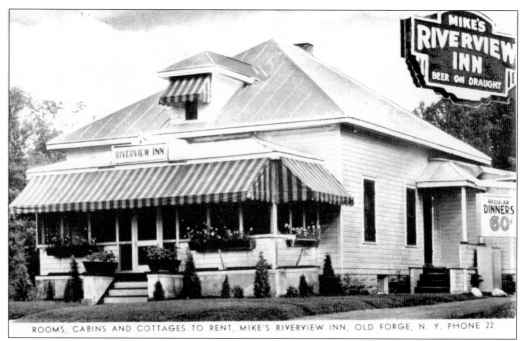

ROOMS, CABINS AND COTTAGES TO RENT, MIKE'S RIVERVIEW INN, OLD FORGE, N. Y. PHONE 22

The Riverview Inn, later renamed the Deerhead Tavern, was located on the banks of the Moose River next to the bridge at the southern entrance to Old Forge. At one time ice cream was manufactured at this site. The building has undergone extensive renovations since the 1950s and, today, is a popular dining spot known as the Old Mill Restaurant.

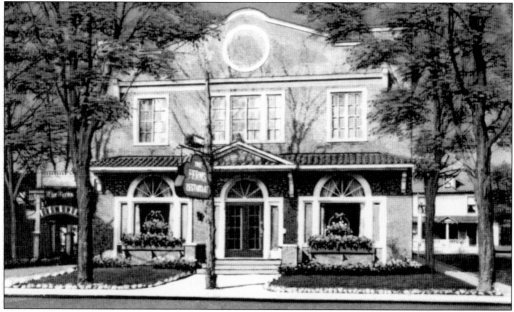

Three generations of the MacFaggan family greeted patrons of the Ferns Restaurant on Main Street. White linen tablecloths and waitresses in black taffeta uniforms gave this establishment a fashionable reputation. Today, the building is the location of Walt's Diner and Frankie's Italian Restaurant.

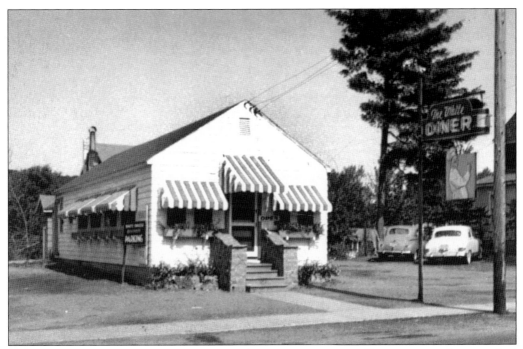

The White Diner has a long history as a popular Main Street eatery. For many years it was owned by the Lorenz family. Today, this well-known restaurant specializes in hearty breakfasts and is called the Keyes Pancake House.

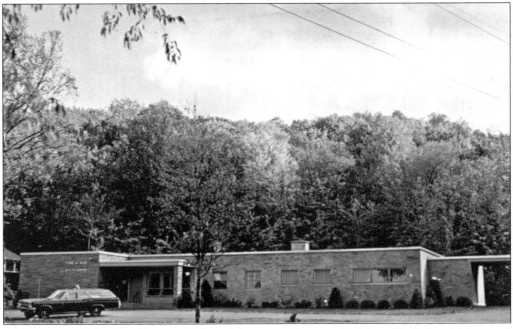

Old Forge was blessed with two dedicated horse-and-buggy physicians: Dr. Stuart Nelson and Dr. Robert S. Lindsay. Lindsay's son Dr. Robert N. Lindsay joined his father's practice in the mid-1920s. In 1963, the Town of Webb Health Center was built under the supervision of Dr. Benjamin Emerson. Today, the facility offers a wide variety of medical services.

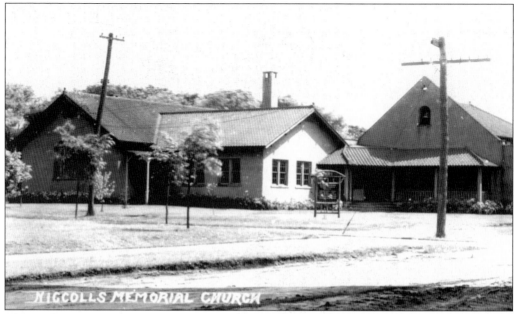

The Presbyterian congregation outgrew the small frame church on Crosby Boulevard early in the 20th century. The congregation moved to this building down the street and, in 1917, renamed it Niccolls Memorial Church in honor of St. Louis clergyman Dr. Samuel Niccolls. Dr. Niccolls had conducted outdoor religious services at his lakeside summer camp for more than 50 years until his death in 1903.

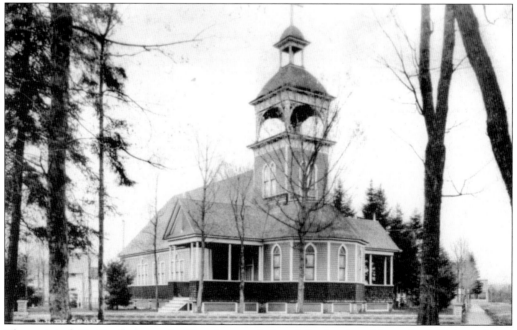

The original St. Bartholomew's Church was designed by local architect Levi Deis and was dedicated in 1897. It served the Roman Catholic community until a new church was constructed in 1991. For more than 100 years, St. Bartholomew's Church has been located at the corner of Crosby Boulevard and Park Avenue.

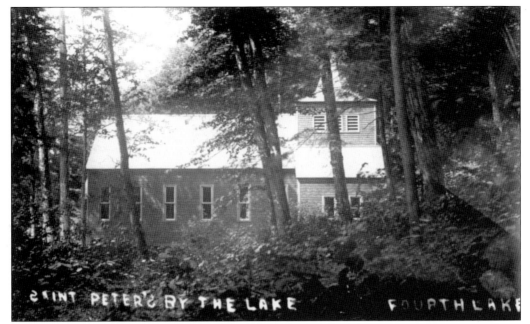

SAINT PETER'S BY THE LAKE FOURTH LAKE

In 1905, Chris Goodsell built St. Peter's by the Lake. The land was donated to the Albany Episcopal Diocese by Dr. and Mrs. William Seward Webb. Tucked into a steep, forested hillside, the church overlooks picturesque Fourth Lake. Until the state highway was completed in 1926, parishioners arrived by boat, as many do today.

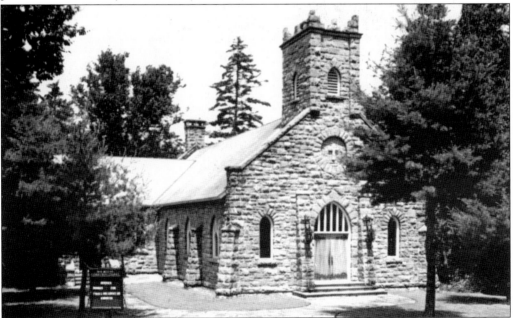

Religious services were held in boathouses, hotels, schools, and railroad stations for the early pioneer families and summer visitors. Big Moose residents raised money to build the Big Moose Community Chapel, which was dedicated in 1931. Without benefit of architectural plans, local builder Earl Covey supervised the construction of the chapel, using native stone from Dart's Mountain.

Sunday services were held on the docks of the Viking Village Resort until 1953, when the Brynilsens built St. Olaf's Chapel. The picturesque structure is a replica of a 14th-century Norwegian church. St. Olaf's is located on the South Shore Road and is one of several area churches that serves summer parishioners.

Five

RESORT HOTELS
AND LODGES

The Arnold House was the first recorded hostelry in the central Adirondack region. It was built as a residence by Charles Frederick Herreshoff in 1811 on a hillside above the Moose River in Fulton Chain at the end of the Brown's Tract Road. The Otis Arnold family moved into the abandoned dwelling in 1837 and offered food and shelter to travelers for the next 30 years. The Forge House, erected in 1871 on the knoll overlooking Old Forge Pond, was the first establishment in the region specifically built to accommodate travelers and vacationers. During the hotel's 53 years of operation, the leather-bound register listed visitors from all over the United States and from many foreign lands. The Forge House was but one of many impressive hotels in the area. In 1948, author David Beetle sat on the hotel porch of the Mohawk with owner Allen H. Wilcox, who, from memory, rattled off some 52 inns, lodges, hotels and guesthouses on Fourth Lake alone.

Vacation styles changed following World War II. Modern motels and housekeeping cottages better suited the lifestyle of automobile travelers. Chapter 5 takes us back to an era when vacations in the grand old hotels were popular in the Fulton Chain region.

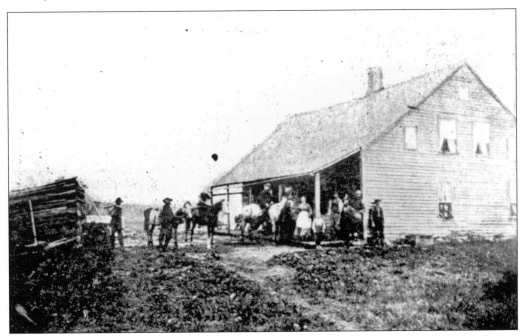

The Arnolds raised their 12 children in this house, in addition to providing food and shelter to trappers, guides, and sportsmen.

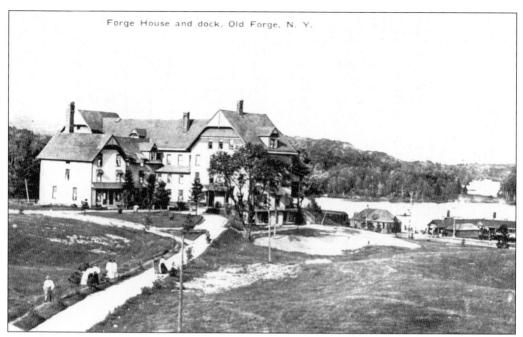

Forge House and dock. Old Forge. N. Y.

The first wing of the Forge House opened in 1871, and 348 people—including 32 women—
— inscribed their names in the hotel register that year. The imposing structure dominated the
lakefront landscape in Old Forge until it burned in 1924.

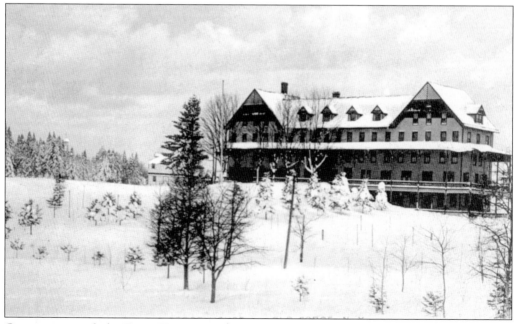

Open year-round, the Forge House served as a gathering place for residents as well as travelers.
Mail was picked up here, and wedding receptions, graduation ceremonies, and other special events
took place inside this landmark structure. Portions of the Forge Motel and Clark's Beach Motel
occupy the site where the Forge House once stood.

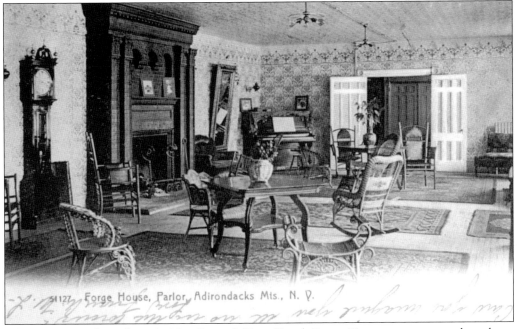

51127 Forge House, Parlor, Adirondacks Mts., N. Y.

After emerging from the primitive Brown's Tract Road, Forge House patrons must have been astonished to enter such an elegant Victorian parlor. In 1900, the Forge House was the first hotel in the region to advertise running water and electricity in every room.

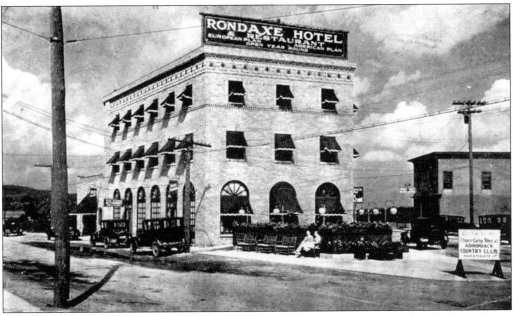

The Rondaxe Hotel stood on the Busy Corner in Old Forge for seven decades. Built in 1926, it was intended to replace the Forge House. The yellow brick building, with decorative Romanesque arched windows, was constructed using the most modern fire-resistant materials. Throughout the building's history, the ground floor housed a variety of business enterprises.

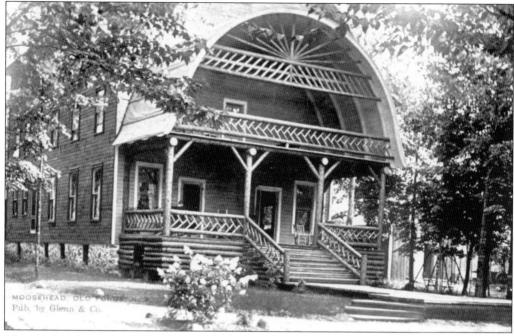

MOOSEHEAD, OLD FORGE, N. Y.
Pub. by Glenn & Co.

The original Moosehead Hotel was built by Sam Smith in 1907 and was called the Hereshoff. The hotel came into the possession of Smith's second wife, Eliza Helmer, following a bitter divorce. Tragically, the ornate building burned to the ground *c.* 1920, and the New Moosehead was built by Eliza Helmer at the same location, near the Town of Webb School. Farther south on the opposite side was the Limberlost Tourist Home, pictured below. Built by W.J. Boardman and operated for many years by Mrs. Boardman, the building was razed in 1987.

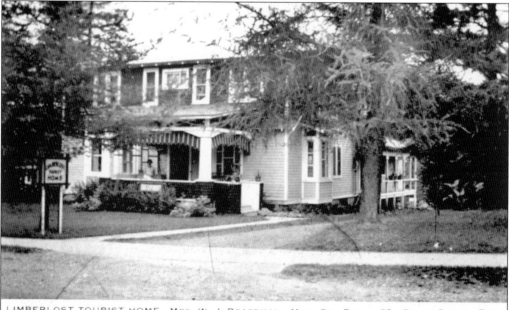

LIMBERLOST TOURIST HOME. MRS W. J. BOARDMAN. MAIN ST. ROUTE 28. SOUTH SIDE OF TOWN OLD FORGE. N. Y. SIMMONS BEAUTY REST MATTRESSES. APPROVED BY PUBLICITY TRAVEL BUREAU

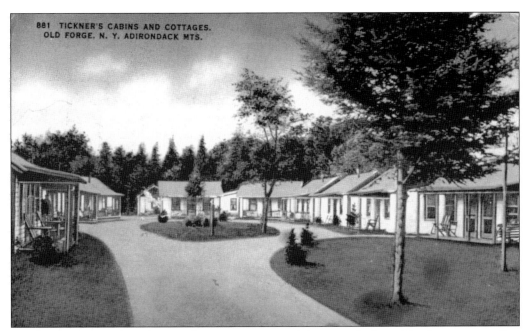

By the 1920s, tourist cabins and cottages were gaining popularity with the auto-traveling public. Tickner's Cabins, in the photograph above, were built by the McNierney family on the lower end of Main Street in Old Forge. Today, they are called the Moose River Cabins. Hemmer Cottages, below, were located on Park Avenue across from the Maple Ridge Ski Hill. Bernard Hemmer designed each rustic cottage to reflect architecture he had seen in Europe. In 2002, the last surviving Hemmer Cottage on this property was saved from demolition and moved to the waterfront.

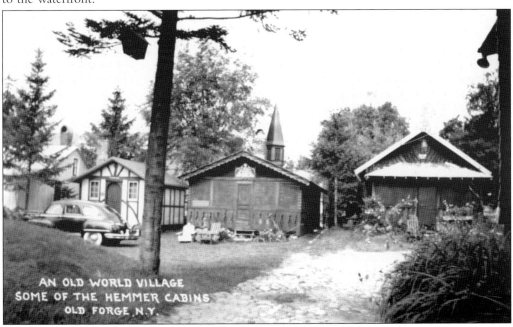

AN OLD WORLD VILLAGE
SOME OF THE HEMMER CABINS
OLD FORGE, N.Y.

73

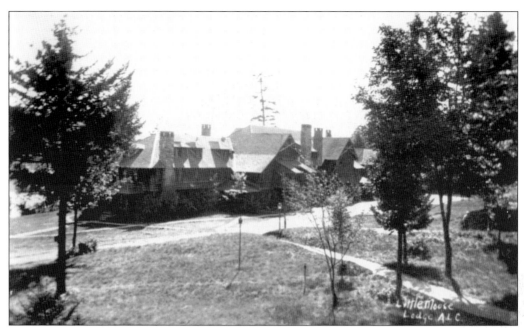

The Adirondack League Club was incorporated in 1890 to acquire a tract of land in the Adirondacks for hunting and fishing. The ALC purchased nearly 200,000 acres of wilderness adjacent to Old Forge. The original clubhouse burned in 1914. For generations, members have stayed in the rebuilt summer lodge, pictured above, the winter lodge, pictured below, or in their own private camps on the preserve.

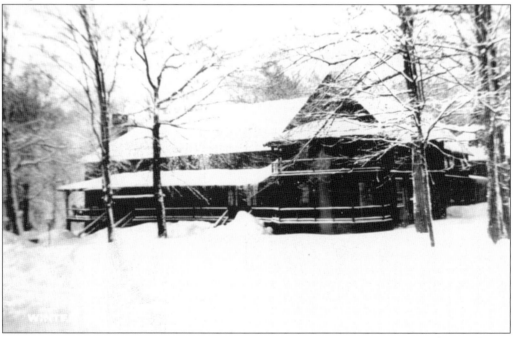

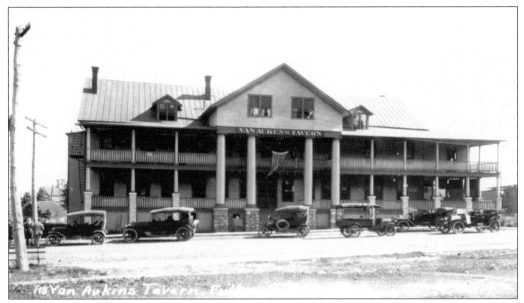

Van Auken's was built in 1891 to house railroad workers. It was located next to the Fulton Chain Railroad station. The Tennis family, proprietors from 1902 to 1907, moved the building across the tracks to its present location. The landmark Thendara hotel has been in continuous operation for more than a century and bears the name of the third owner, Charles Van Auken, misspelled in the text on the postcard.

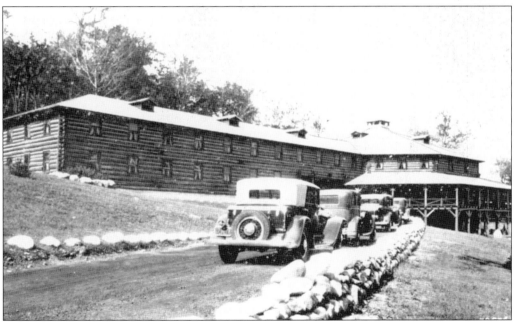

The Hollywood Hills Hotel on First Lake was built in the 1930s by real estate developer Joseph Young. The massive log structure, with a 62-foot-high four-sided fireplace in the lobby, was a popular night spot, drawing nationally known celebrities to perform at its lakeside casino. Numerous lots surrounding the hotel were sold for private camps. The hotel has since been converted into condominiums.

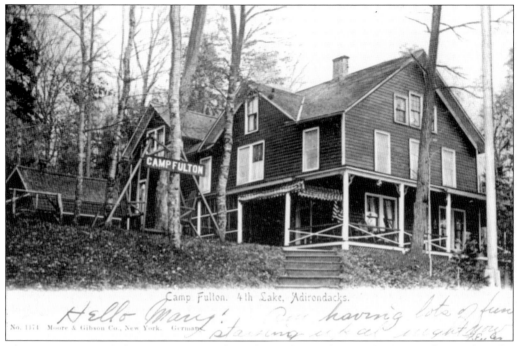

Camp Fulton. 4th Lake, Adirondacks.

Hello Mary! *Am having lots of fun staying up all night now. F.E.*

No. 1171 Moore & Gibson Co., New York. Germany.

This 1906 postcard features Camp Fulton, located on the north shore of Fourth Lake. Built in 1896, the small hotel was owned by the Payne family for decades and catered to a loyal clientele. The property was purchased in 1956 by the Daiker family, who operate it as a popular year-round restaurant.

The North Woods Inn on Fourth Lake was built at the beginning of the 20th century and was first called the Onondaga. In 1937, it was remodeled and redecorated by new owners, the Foley family, who operated the resort for many decades. North Woods and Holl's Inn are the last full-service hotels remaining on Fourth Lake.

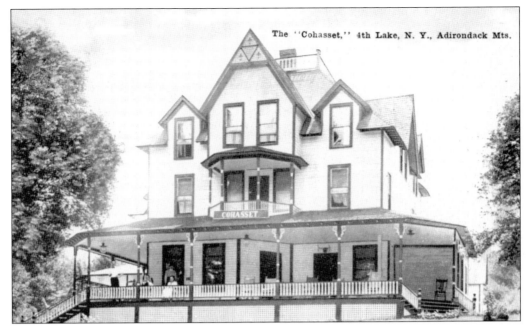

The ''Cohasset,'' 4th Lake, N. Y., Adirondack Mts.

Cohasset Hotel was built by Josiah Wood on a peninsula of land he purchased in 1887 on Fourth Lake's south shore. Cottages were built near the hotel to accommodate overflow guests. French actress Claudette Colbert once worked as an au pair at Cohasset. Although the hotel was dismantled in the 1980s, many of the original cottages remain as private camps.

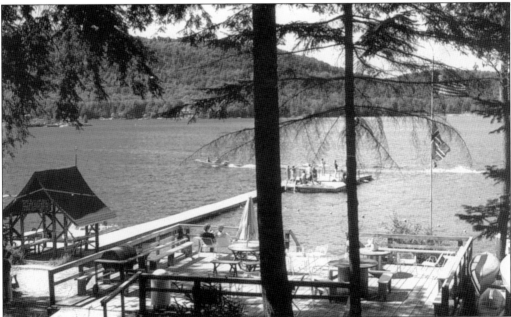

This is a photograph of the busy Viking Village waterfront, located on the south shore of Fourth Lake. In 1900, Mel Aldrich built Camp Monroe at this site and operated the hotel until 1941. In 1945, the property was sold to Al Brynilsen, who changed the name to Viking Village. Brynilsen, with his father, Olaf, and son Rolf, added 17 housekeeping cottages to the resort. Each summer Rolf Brynilsen and his wife, Jan, continue to greet their loyal clientele.

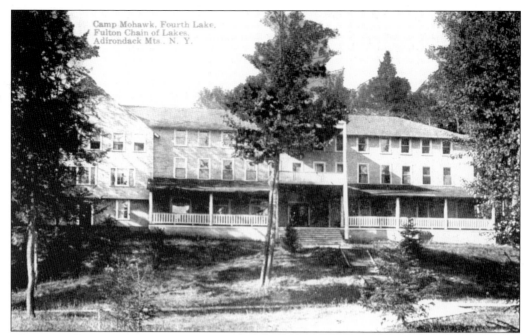

The original Camp Mohawk was built in 1897 by Herbert H. Longstaff. From 1933 to the mid-1970s, the hotel was operated by the Allen Wilcox family. In its heyday it was one of the most exclusive summer resorts on the Fulton Chain. Much of the original building remains unchanged, and it is now a summer camp for the hearing impaired called Camp Mark Seven.

Dwight Bacon Sperry arrived in the Adirondacks in the 1890s and worked as a teamster hauling supplies needed to build the railroad. This interesting man soon built a hotel in Big Moose called the Glennmore and then purchased the Eagle Bay Hotel property on Fourth Lake. In August 1945, guests fled the Eagle Bay Hotel in the middle of the night when the old wooden structure burned to the ground.

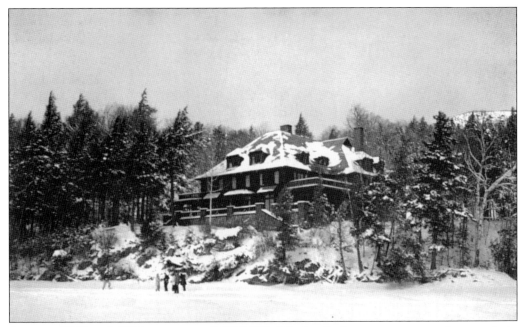

Between 1927 and 1930 at a cost of $500,000, Albedor Lodge was constructed as a private residence for Col. and Mrs. Edward Simmons. It was named for the three Simmons daughters: Aline, Betty, and Doris. In 1956, Hans and Anna Holl purchased Albedor Lodge and converted it to a charming hotel and restaurant. Today, it is once again a private residence.

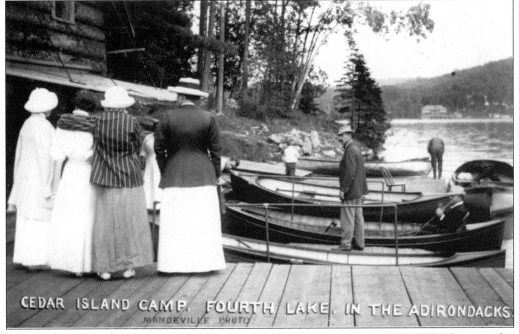

CEDAR ISLAND CAMP. FOURTH LAKE. IN THE ADIRONDACKS.
MANDEVILLE PHOTO.

In 1871, Fred Hess built a rustic shanty to accommodate guests on Cedar Island. From this humble beginning, Cedar Island Camp was expanded and operated as a full-fledged hotel until it burned in 1915. Later, under the ownership of Dr. George Longstaff, it was converted to a boys' sleepaway camp, with a special emphasis on sailing. The island is now privately owned.

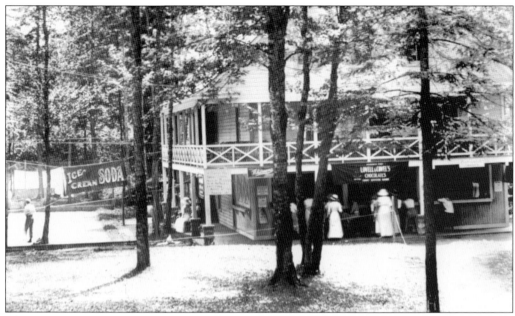

The Wood Hotel, built in 1897, was another of Fred Hess's Inlet projects. Hess called the hotel the Hess Inn. By 1906, new owner Philo Wood had renamed it the Wood Hotel. This photograph pictures the waterfront casino refreshment stand adjacent to the tennis court. The old hotel building still stands but has been vacant for a number of years.

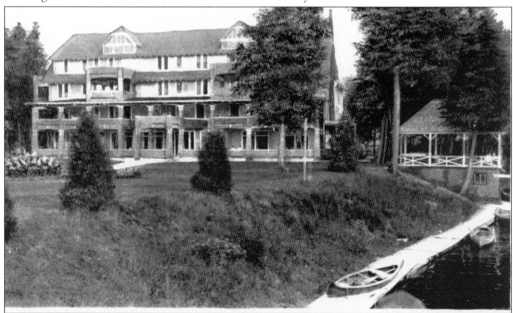

The Arrowhead Hotel was constructed by Fred Hess at the head of Fourth Lake in 1895. Destroyed by fire in 1912, it was rebuilt by Charles O'Hara. The hotel catered to patrons of the highest class. It gained notoriety following publication of Theodore Dreiser's novel *An American Tragedy*. The novel was based on the 1906 murder of Grace Brown at Big Moose Lake. Chester Gillette, Brown's lover and murderer, fled through the woods to the Arrowhead Hotel, where he was arrested several days later.

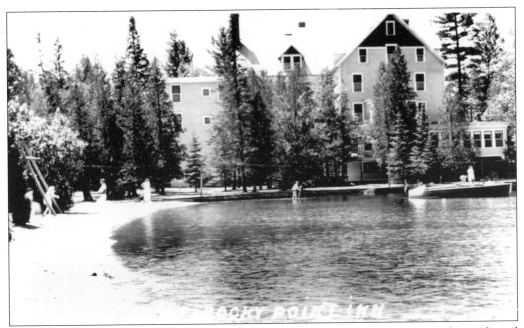

Arch Delmarsh trekked into the wilderness at the age of 21 and worked as a popular guide and manager of the Cedar Island Camp. In 1911, he purchased the Rocky Point Inn, built in 1892 by the Mark Niles family. Two subsequent generations of the Delmarsh family ran the Rocky Point Inn until 1987, when the hotel was demolished to make room for lakeside condominiums.

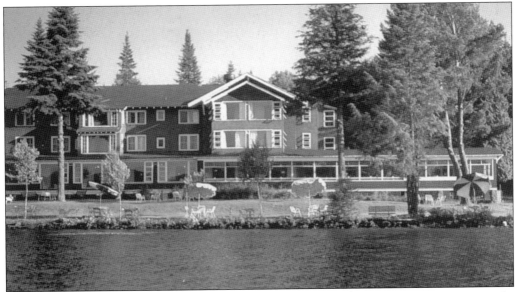

Holl's Inn was originally built as a private camp for Standard Oil president Charles Pratt. The building was converted into a hotel by Charles O'Hara, who gave it the name Araho (O'Hara spelled backwards). Oscar and Hans Holl purchased this old-fashioned resort in 1935. After all these years, the Holl family continues to operate this very special Adirondack resort.

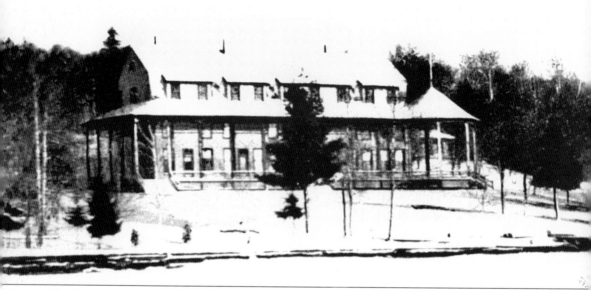

Charles Barrett bought property on the north shore of Third Lake in the 1890s and built the Bald Mountain House. This impressive hotel featured delicious meals, an orchestra that played every

51582 General View of Darts Camp, Adirondack Mts., N. Y.

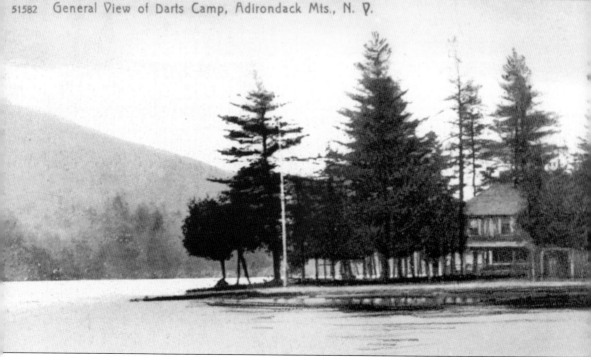

In 1879, pioneer guide William Dart constructed a camp on the Second Lake of the north branch of the Moose River. Most of the structures were built from unpeeled logs harvested and milled

evening, and its own bowling alley. The property is still owned by the Barrett family, though the hotel was taken down in the 1960s.

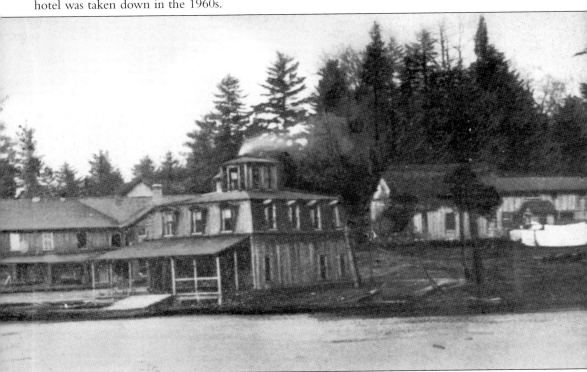

on the site. Dart's is known today as Camp Gorham, a YMCA summer camp.

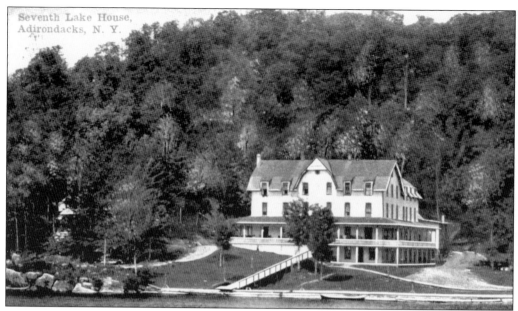

The Seventh Lake House was built *c.* 1900 by Duane Norton, but longtime owner Frank Breen added the semicircular dining room and porch shown in this 1910 photograph. The hotel was located on the north shore just past the bridge between Sixth and Seventh Lakes. Other owners of the Seventh Lake House included Charlie Williams of Big Moose and his son-in-law J. Perry "Pitt" Smith. The hotel was destroyed by fire in 1954.

Kenwell's was located deep in the wild forestland of the Moose River Plains north of Inlet. Visitors, who traveled in by foot or on snowshoes, could always count on a warm greeting and a tasty meal from the legendary hermit "Mayor" Gerald Kenwell. So remote was this establishment that Kenwell made supply trips into Inlet only three times a year.

84

Six

SUMMER RECREATION

At the beginning of the 20th century, large tracts of land were subdivided into smaller parcels and purchased by seasonal property owners. William Thistlethwaite's Adirondack Development Corporation sold hundreds of lots in the hamlet of Old Forge along the north shore of the Fulton Chain and northward to Rondaxe Lake and Big Moose. The deCamp family sold its landholdings in the Okara Lakes area and along First Lake at Hollywood Hills. Visitors came to enjoy the recreational activities that draw summer residents and tourists today.

For more than 75 years, tens of thousands of youngsters packed footlockers and duffel bags for summer vacations at children's camps in the Old Forge region. These energetic visitors participated in a wide variety of activities, including hiking, swimming, sailing, canoeing, tennis, horseback riding, and arts and crafts. The card below was sent to "Grandma" in 1935 from a young camper staying at Adirondack Woodcraft Camp. Woodcraft Camp opened in 1926 and has since hosted campers from every state and nearly 50 countries.

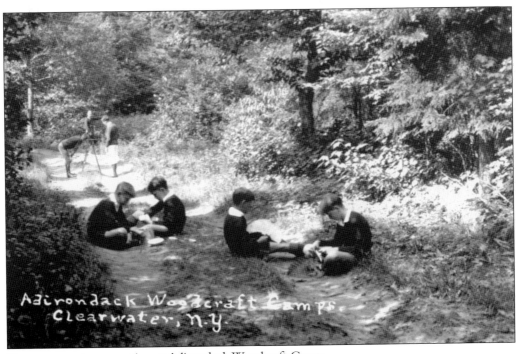

Youngsters enjoy an outing at Adirondack Woodcraft Camp.

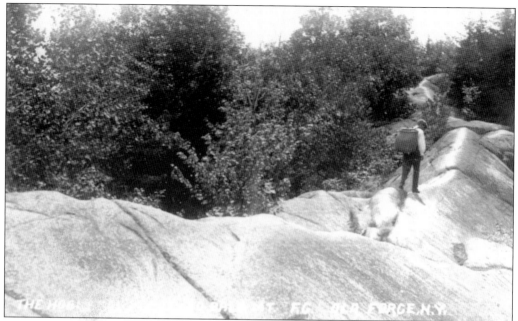

A lone hiker makes his way across the Hogsback section on Bald Mountain in 1912. This popular climb is taken by thousands of people each year to view the Fulton Chain of Lakes. Miles of hiking trails in the Old Forge region follow routes carved out two centuries ago by early hunters and trappers.

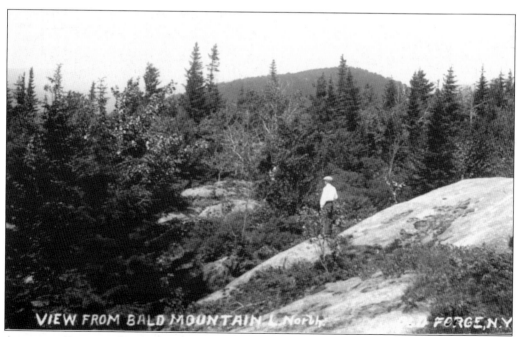

A summertime view from Bald Mountain overlooking the lakes contains many shoreline camps and boaters. The vast expanse to the north reveals thousands of acres of uninhabited, forever wild forest preserve.

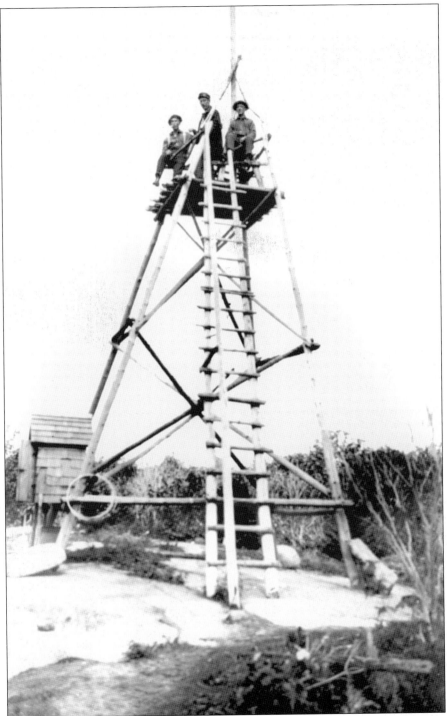

In the 1870s, Bald Mountain was the principal summit in the region used by the well-known New York State Adirondack surveyor Verplanck Colvin. Surveyors erected wooden towers to help them calculate distances and the heights of peaks. Later, steel towers were used for fire spotting. A Colvin survey marker remains embedded in the granite on the summit of Bald Mountain.

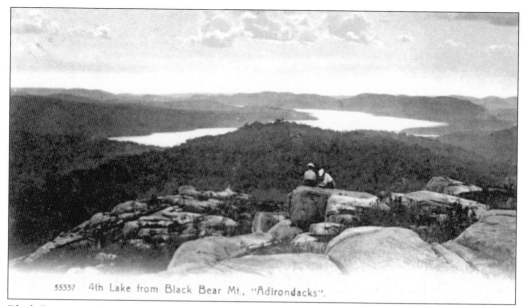

55337 4th Lake from Black Bear Mt., "Adirondacks".

Black Bear is another frequently climbed local peak with magnificent views of the Fulton Chain. The most popular access to this summit is from the trailhead on the Uncas Road just north of Eagle Bay.

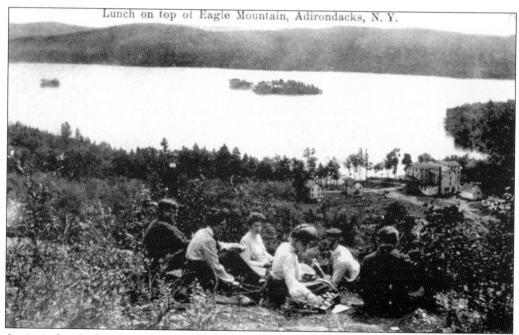

Lunch on top of Eagle Mountain, Adirondacks, N. Y.

A picnic lunch shared with friends is especially enjoyable on a central Adirondack peak such as Eagle Mountain. This was a favorite hike for guests at the Eagle Bay Hotel, pictured in the foreground. Legend has it that two tall pines once graced this mountaintop. Eagles nested here every year until, one autumn, a heavy windstorm took the two trees down.

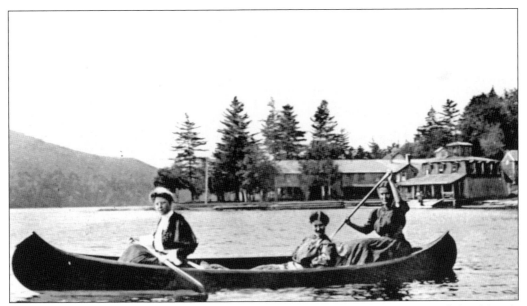

In the Adirondacks, canoes are the most frequently used small boats. Most of the lakeside hotels provide canoes for their guests. These women appear to be enjoying their outing on Dart's Lake.

Reading is a favorite Adirondack pastime. The peaceful surroundings of Cedar Island on Fourth Lake provide a wonderful spot for this early-20th-century visitor to wile away the hours with a good book.

Open camps, lean-tos, or wikiups provided basic shelter for hunters, trappers, and guides. By the early 20th century, these rustic structures had become familiar gathering places for socializing at the end of the day. Private camps and hotels often featured lean-tos in which friends could gather and tell tall tales in front of an open fire.

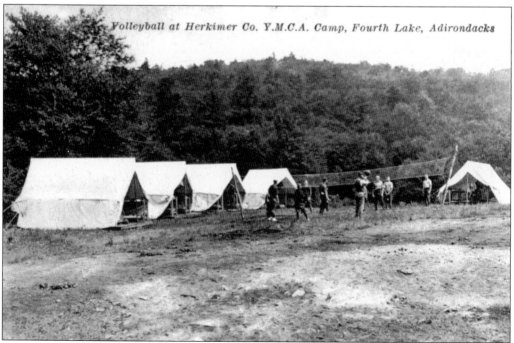

Volleyball at Herkimer Co. Y.M.C.A. Camp, Fourth Lake, Adirondacks

Tents provided shelter for many summer campers. This Herkimer County YMCA group is enjoying a game of volleyball. Earlier, the campsite had been the location of the Manhassit Hotel; today, it is the site of the Fourth Lake state boat launch and picnic area.

The Thendara Golf Club was organized in 1921. Nine holes were constructed on land donated by Lyon deCamp. In 1958, the course was expanded to include nine holes along the Moose River. In the 1960s and early 1970s, the club held exhibitions that featured golf legends Sam Snead, Arnold Palmer, Jack Nicklaus, Lee Trevino, and others.

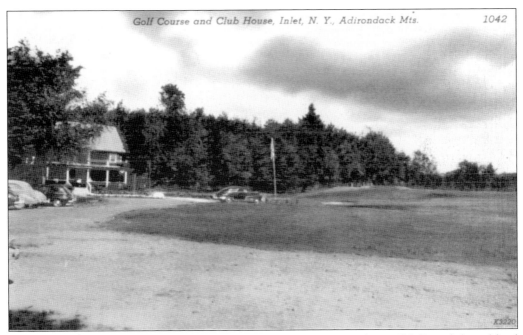

Golf Course and Club House, Inlet, N. Y., Adirondack Mts. 1042

The first nine holes of the Inlet Golf Course were built in 1926. The availability of cleared land and the growth in tourism convinced local businessmen to invest in the new club. Later, it was enlarged, but it was not until 1985 that the course was permanently expanded to 18 holes. Today, this beautifully maintained course is a very popular spot.

The Fulton on Fourth Lake, like many area hotels, catered to families. Often hotels hired recreational staff to organize children's activities and to teach swimming, tennis, and boating. The Fulton also provided swings and slides and simple pastimes such as croquet.

The Old Forge region has a long history of tennis. Records indicate tennis courts were available to hotel guests in the early part of the 20th century. Tennis enthusiasts looked forward to annual tournaments organized by local resorts. The Old Forge Art Center continues the tradition by hosting a tournament each summer.

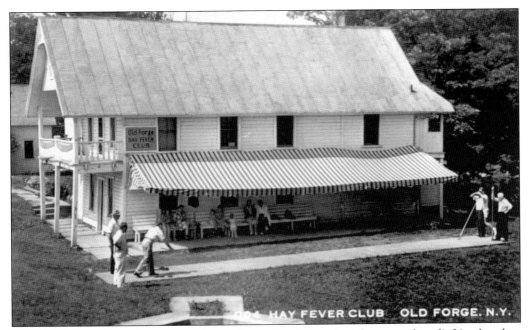

Before the days of antihistamines, those who suffered from hay fever sought relief in the clear mountain air. The Hay Fever Club, which numbered more than 600 members at one time, met annually in Old Forge at the former fish hatchery, located just below the dam.

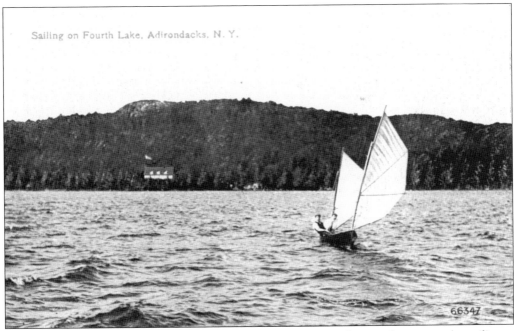

Sailing races are a Fourth Lake tradition. Choppy waters and gusty breezes make sailing a double-masted canoe quite a challenge. This type of watercraft is seldom seen on the lakes today.

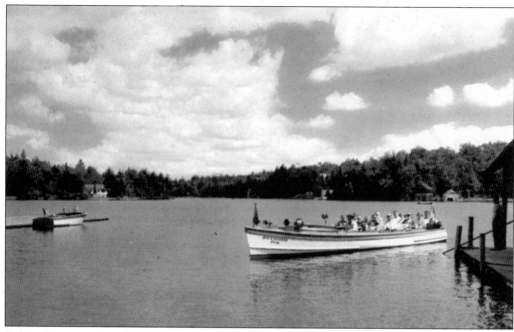

A favorite way to see the Fulton Chain during the 1940s and 1950s was aboard these handsome motorized launches. Passengers were picked up from and returned to the municipal dock at Old Forge Pond.

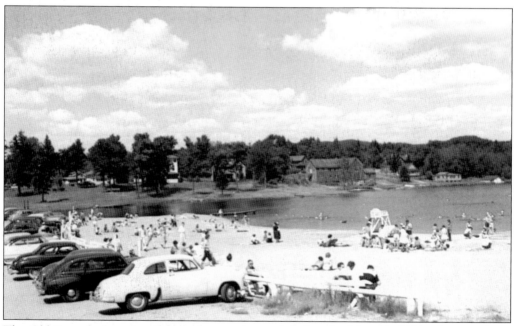

The Old Forge bathing beach was a busy and crowded place in this early 1950s photograph. In the mid-1950s, voters in the Town of Webb approved a bond issue to build an information center and a bathhouse and to make other improvements along the lakefront.

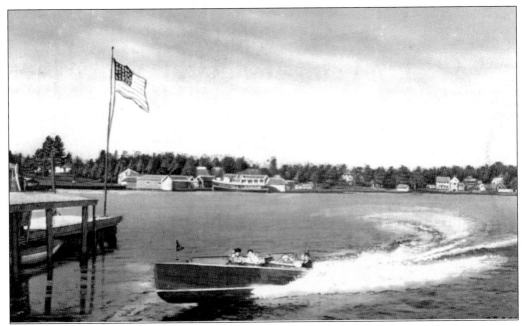

Speedboats provide excitement on the lakes. As early as the 1920s, speedboats pulled aquaplanes; later, they pulled water-skiers. Races were also popular. Every summer an antique boat show and parade draw hundreds of spectators to the Old Forge waterfront to view classic watercraft, such as the boat pictured here.

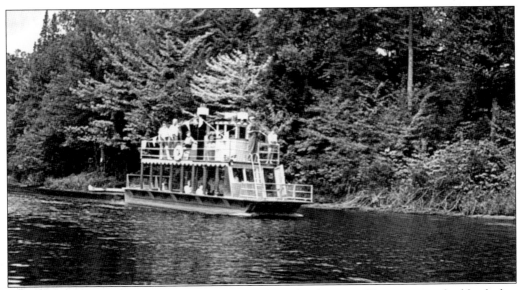

In 1959, Donald Lorenz began operating the *Showboat,* a 50-passenger double-decker riverboat offering 45-minute excursions. For several years the boat cruised the lower middle branch of the Moose River.

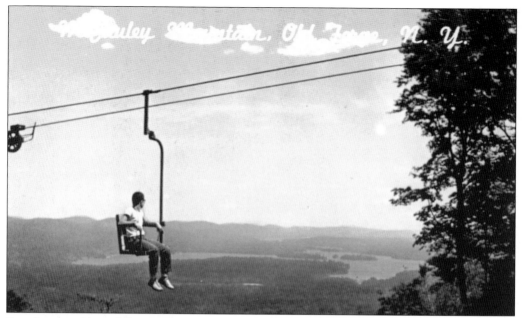

For those unable to hike to a mountain summit, the McCauley Mountain chairlift provides a wonderful view of the Old Forge region. The chairlift operates in the winter for skiers and in the summer and fall for sightseers. It is a spectacular way to see the fall foliage.

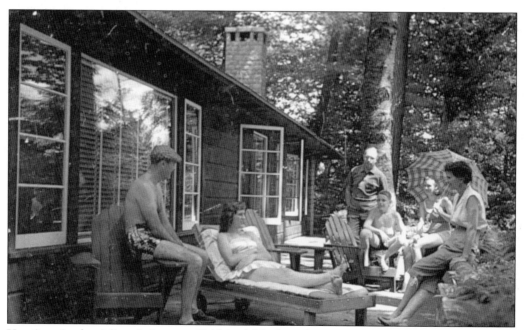

Vacations in the Adirondacks were "laid back" before the term was popularized. Families and friends socialize, have reunions, and celebrate special occasions. Here, guests enjoy leisure time on the porch in the sun at the Mohawk Hotel.

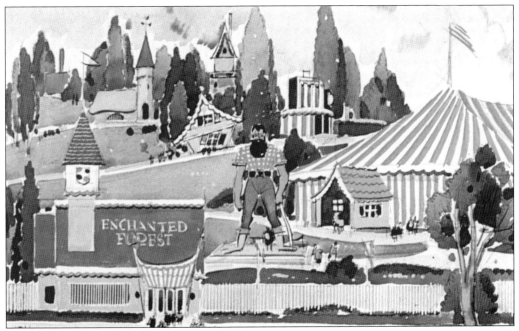

The Enchanted Forest opened in 1956 as a family amusement park. It featured woodland trails past storybook characters' homes and a miniature train ride. The original designs were created by New York designer Russell Patterson. Many of the later additions were the creations of local designer Charlie Gillette.

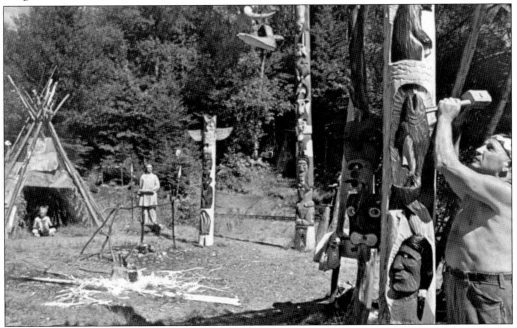

Chief Maurice Dennis is pictured here carving a totem pole in the Abenaki Indian Village at the Enchanted Forest. Other entertainments included staged shoot-outs at the Yukon Village and raids at the pirate ship. For many years the famed high-wire act the Flying Wallendas performed at the Enchanted Forest.

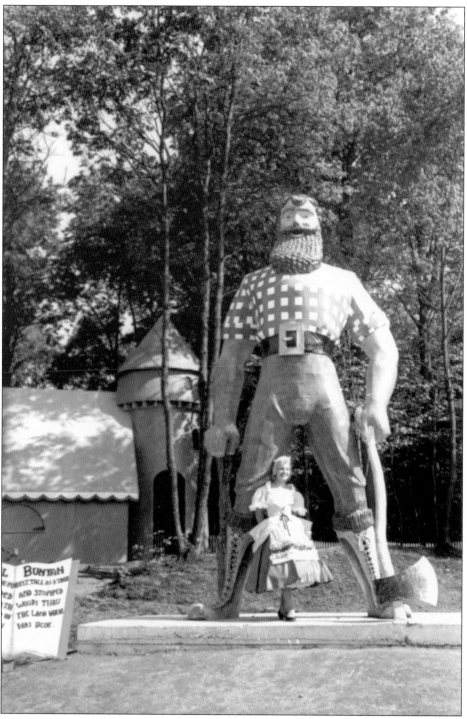

BUNYAN

This 30-foot statue of Paul Bunyan, the legendary lumberjack, is still a popular spot for photographs. Storybook characters, such as the enchanted princess, added to the delight of children. With the addition of water rides in the 1980s, the park, now called the Enchanted Forest–Water Safari, thrives today.

Seven

WINTER RECREATION

For the first few decades of the 20th century, the winter population of Old Forge was reduced to a handful of hearty souls who braced themselves for the long, desolate snow season. The majority of the businesses and hotels were boarded up until the next summer season brought another wave of tourists. World War I forced the closing of several sawmills, as able-bodied men left to serve in the armed forces. One essential task in the autumn for those who stayed was to lay in a good supply of wood for the stoves that heated the poorly insulated wood-frame houses.

In 1932, the Winter Olympics at Lake Placid put the Adirondack Mountains on the front page of national and international newspapers. Caught up in the enthusiasm for winter sports, the residents of Old Forge organized a Winter Sports Association to promote recreational activities and boost the local economy. Public funds and private donations were used to hold annual week-long winter carnivals and to build ski trails, toboggan runs, and skating facilities. Winter recreational activities continue to draw thousands of sports enthusiasts today—particularly snowmobilers, who have labeled Old Forge the "Snowmobile Capital of the East."

Old Forge has four distinct seasons: spring, summer, fall, and winter. Sometimes in April you can experience all four.

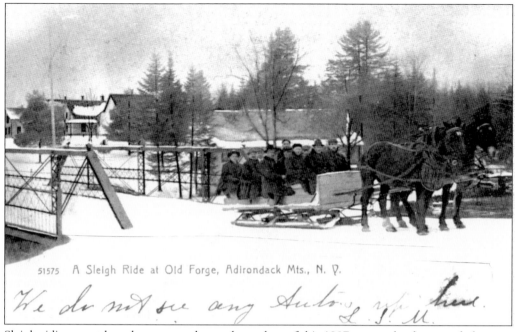

51575 A Sleigh Ride at Old Forge, Adirondack Mts., N. Y.

We do not see any Autos up here. L. J. M.

Sleigh riding must have been a novelty to the author of this 1907 postcard, who scrawled a note indicating there were no autos up here. The photograph was taken at the bridge near the Old Forge Dam.

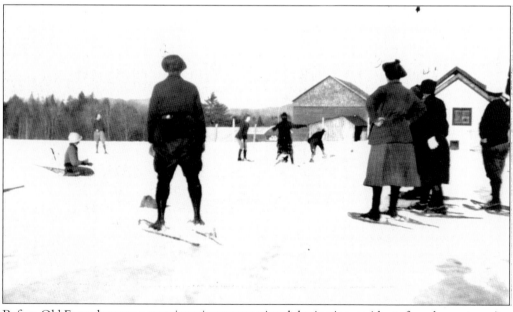

Before Old Forge became a premier winter recreational destination, residents found ways to enjoy the splendor of their winter paradise. In the 1920s, a group of local girls combined two popular sports: snowshoeing and baseball. The playing field was behind the Strand Theater, where the Old Forge Library is now located.

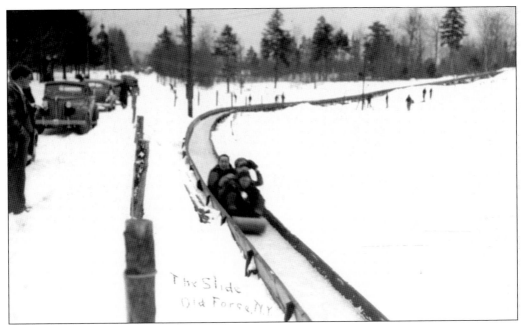

Several toboggan slides were built in the 1930s, including one at the Eagle Bay Hotel and another at the Inlet waterfront. The first toboggan slide in Old Forge started from the top of the slope above the Old Forge Pond. This slide was located at Maple Ridge on Park Avenue. The photograph was taken in 1937.

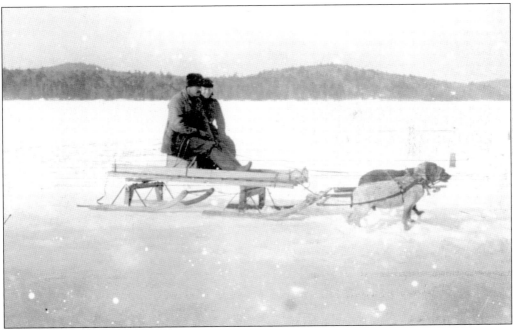

All sorts of winter activities took place on the frozen lakes. Sleds carrying freight were usually drawn by horses. The dogsled here was probably used only for recreation, although a few bags of groceries would fit neatly in the rear.

Beautiful Gray Lake, at the foot of McCauley Mountain, was the setting for this winter picnic. Local hotels and boardinghouses were happy to pack box lunches for winter sports enthusiasts.

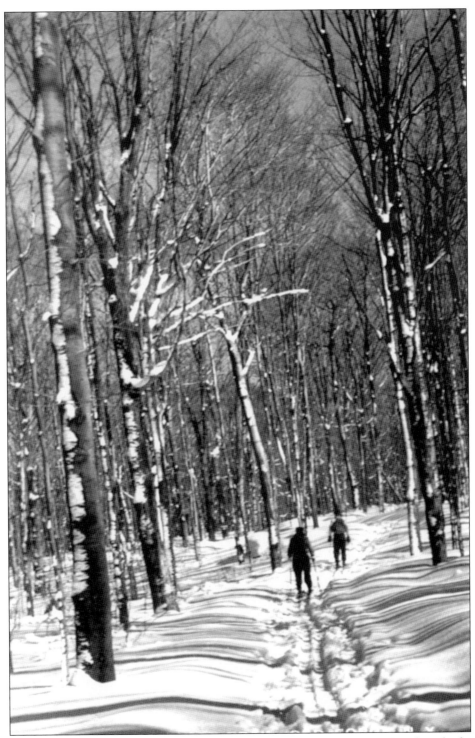

Andrew Grindland, a Norwegian immigrant, moved to Fourth Lake in 1910 and made the first known pair of skis in the region. Ski touring, or cross-country skiing, gained in popularity when trails were cleared in 1930s. Here, skiers traverse a forested trail near Old Forge.

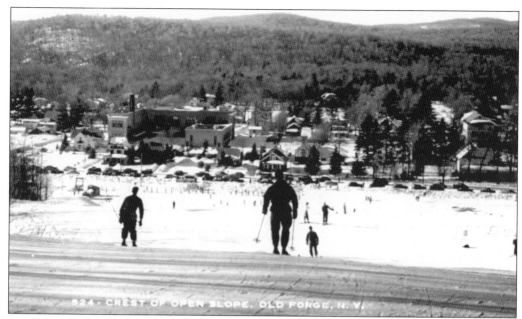

Since the Maple Ridge ski hill was located across the street from the school, skiing became part of the physical education curriculum. In 1939, Swiss-born Max Bolli was hired as a ski instructor for the students. He also offered private lessons using his legendary mantra, "Bend-ze-knees, three dollars please!"

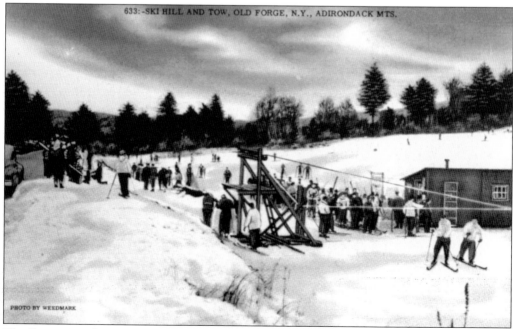

The lines at Maple Ridge were not long by today's standards, and the price was right—a penny a ride. In the winter of 1940–1941, new bride Judy Cohen collected fares at the bottom of the rope tow while her husband, Dick Cohen, drove the engine at the top. Winter evenings were spent rolling the pennies.

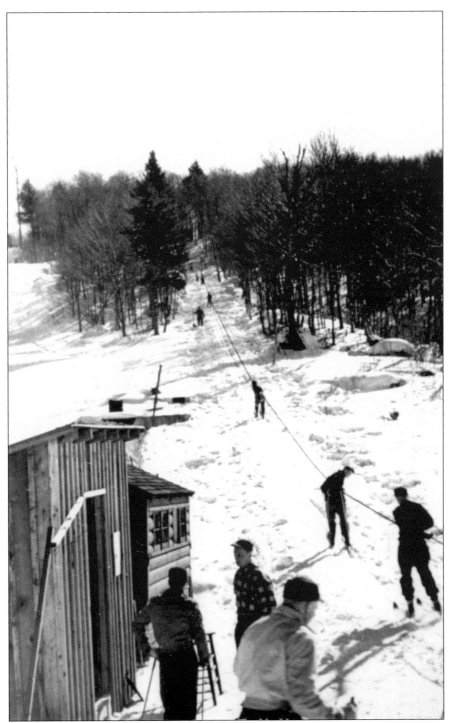

The Forge House slope served as the first ski hill in Old Forge. Maple Ridge was cleared for skiing in 1938. The rope tow pictured here continued to operate into the 1960s. Many talented junior skiers, including Olympians Louie Ehrensbeck and Hank Kashiwa Jr., began their sports career at Maple Ridge.

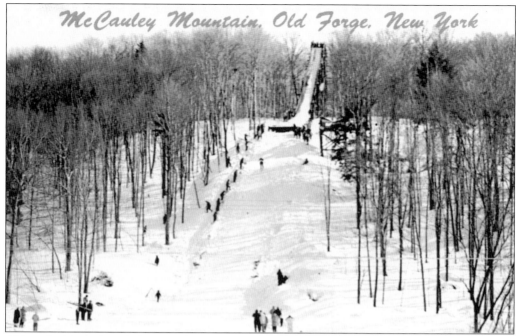

McCauley Mountain, Old Forge, New York

Although this card is titled McCauley Mountain, the ski jump was actually located adjacent to the Town of Webb Health Center. During the 1950s and 1960s, many sanctioned jump meets were held here. Ski jumping was thrilling for the participants and spectators alike.

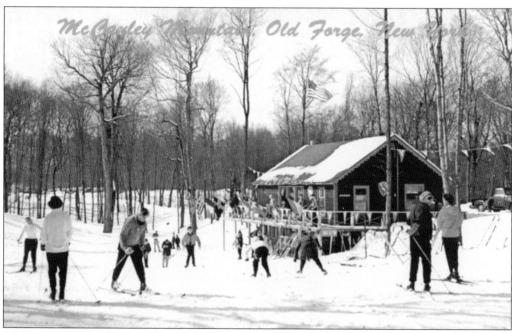

McCauley Mountain, Old Forge, New York

This is a photograph of the first chalet at McCauley Mountain. Over the years the building has been enlarged and now includes a ski shop and a ski school. McCauley Mountain was developed by the Town of Webb in the late 1950s and excels as a family-oriented ski area.

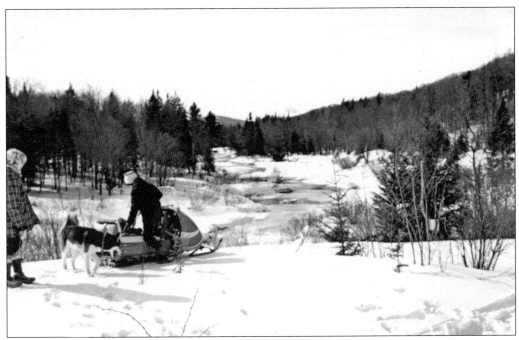

Snow machines were first used in the area by lumbermen going out to mark trees. Recreational snowmobiling became popular in the 1960s. Here, a couple enjoys an outing along the river. Today, Old Forge maintains more than 500 miles of groomed snowmobile trails.

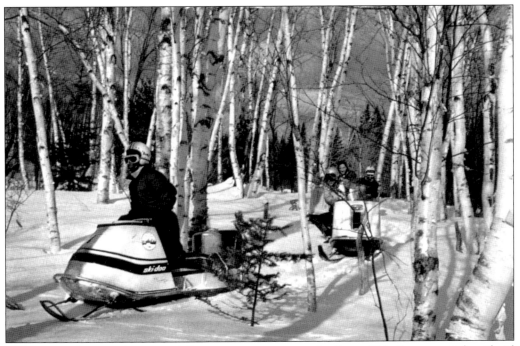

This 1969 photograph memorializes a cross-country trip from Old Forge to Lake Placid undertaken by four local high school students: Mike Marleau, Bucky Kashiwa, Danny Smith, and Tom Crofut.

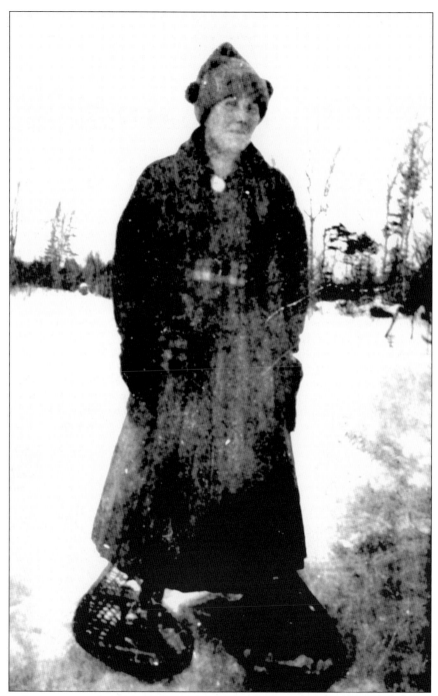

For early pioneers, snowshoeing was the only means of moving about during the long winters. In 1900, Chief Jules Dennis and his wife, Cleo, pictured in this photograph, were among a group of Abenaki Native Americans who came from Canada to the Fulton Chain region to sell hand-crafted souvenirs such as baskets and snowshoes. The Dennis family later became permanent Old Forge residents. Today, winter sports enthusiasts have developed a renewed interest in snowshoeing.

Eight

NEIGHBORING COMMUNITIES

Old Forge is home to nearly 1,000 residents, making it the most populated hamlet in the central Adirondacks. It is also the commercial center of the region, with numerous family-owned small businesses. Some Old Forge natives proudly trace their heritage back four or five generations to families who settled in more remote locations deeper in the woods. During the heyday of logging and rail travel, Middle Settlement, Onekio, Moulin, Carter Station, Big Moose Station, Beaver River, and Brandreth Station bustled with people and activities. Most of these settlements at one time boasted a post office, a school, stores, hotels, lodges, and permanent homes.

A century ago, Grassy Point was a "suburban" settlement on the Stillwater Reservoir and a stop on the Adirondack Division of the New York Central Railroad. "Pop" Bullock, proprietor of the Grassy Point Hotel, shown in the photograph below, provided lodging for wilderness tourists and buckboard transportation to Beaver River camps.

Some of the region's neighboring communities have survived and prospered. Others such as Grassy Point are but overgrown clearings along a lakeshore or in the woods. A few seasonal communities have evolved on nearby lakes and formed associations to address common goals. In this chapter, we will pay a visit to our neighbors and share a bit of their history.

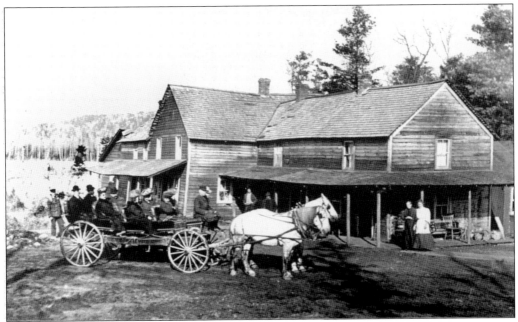

Grassy Point was a "suburb" of Beaver River in the early 20th century.

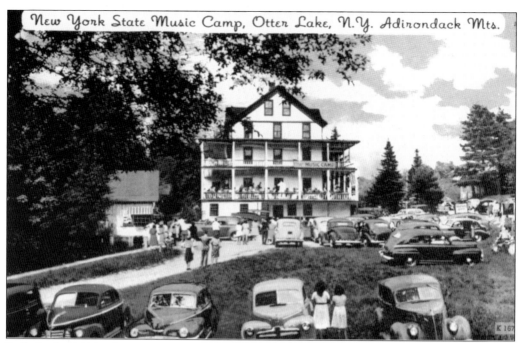

New York State Music Camp, Otter Lake, N.Y. Adirondack Mts.

Built in the 1890s, the Otter Lake Hotel was conveniently located between the railroad station and the lake. It was truly the center of town. In the 1940s, the state purchased the property. For the next nine years, Hartwick College operated it as the New York State Music Camp. Popular concerts attracted thousands each summer. In 1959, the building was destroyed by fire.

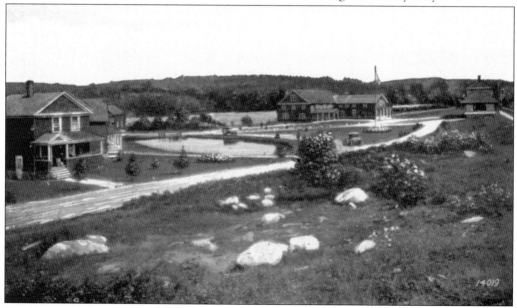

The tiny hamlet of McKeever, named after a railroad employee, was established in the 1890s. Former governor John Dix built the first sawmill on the Moose River. G.H.P. Gould purchased the mill *c.* 1917 and expanded the company town. At one time McKeever boasted a boardinghouse, a general store, a post office, numerous company homes, a school, and a railroad station. In 1961, the entire hamlet was sold at auction.

The Okara Lakes, just south of Thendara, were owned by early-20th-century lumber and land baron Lyon deCamp. DeCamp hired H. Van Buren Magonigle, architect for the U.S. Embassy in Tokyo, to design the Okara Tea Room and several dozen small camps. Magonigle drew up architectural plans that called for oriental upswing roofs, which he believed would look nice in the woods. The Tea Room no longer exists, but several of the original Okara camps, distinguished by their Japanese-style roofs, have survived to this day.

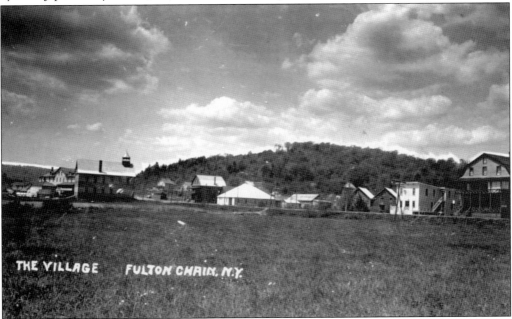

THE VILLAGE FULTON CHAIN, N.Y.

Fulton Chain, renamed Thendara in 1920 by Lyon deCamp, was first cleared in the early 1800s by C.F. Herreshoff. By the end of the 19th century, it was home to three bustling sawmills and was the hub of transportation to the lake area. Most of the vintage Thendara wood-frame structures that exist today were built by the Pullman and deCamp families to house their mill employees.

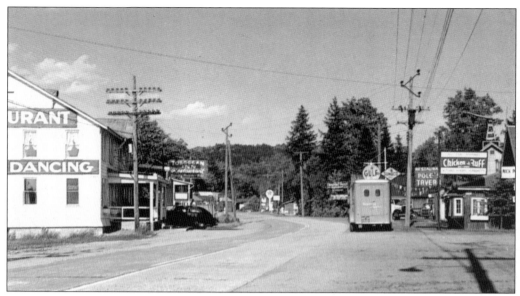

From Route 28, Eagle Bay looks much like this today. Beginning in 1915, developer Howard C. Weller carved out building sites and installed utilities. By 1929, there were 78 camps, cottages, and dwellings and 12 business establishments. Development slowed during the Depression and World War II years but resumed in the late 1940s. Many of the original structures from the Weller period exist today.

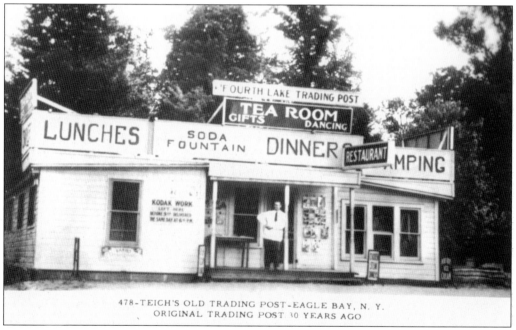

478-TEICH'S OLD TRADING POST-EAGLE BAY, N. Y.
ORIGINAL TRADING POST 30 YEARS AGO

The Frank Teich family arrived in Eagle Bay in 1915 and opened a roadside stand and gift shop. Frank Teich learned taxidermy by correspondence, and before long, stuffing and collecting animals became an obsession. The Old Trading Post charged no admission, but few visitors departed without stopping at the bar, where they could imbibe while gazing up at Teich's odd and curious collection.

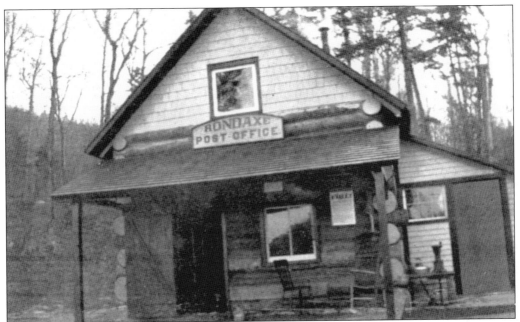

The post office is the central gathering place in most rural towns. In Rondaxe, it *was* the town and was located on the southwest corner of Rondaxe Lake on property owned by year-round resident Edward "Shady" Black. Some of the Rondaxe property owners have family ties dating back to the beginning of the 20th century, when lots were first sold along this pristine lakeshore.

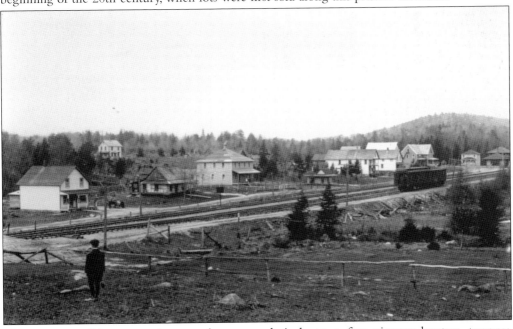

This remote wilderness region was known exclusively to a few pioneer hunters, trappers, and fishermen until the railroad arrived in 1892. Big Moose Station was soon overwhelmed by tough, rowdy groups of loggers and railroad workers. Only a few of the original hotels, saloons, and other early-20th-century buildings shown in this photograph of Big Moose Station remain today.

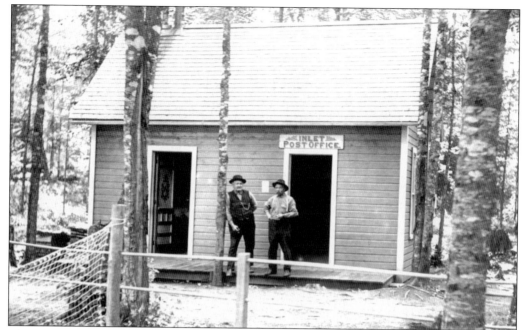

The town of Inlet celebrated its 100th anniversary in 2002. It is the second largest community in the region. In 1907, this postcard was sent to Mrs. A.M. Delmarsh, wife of the proprietor of Cedar Island Camp. At that time all incoming mail and packages arrived at this post office by boat.

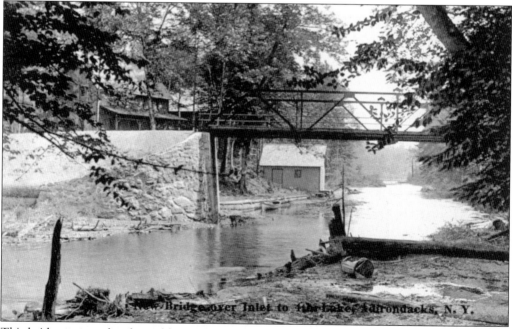

This bridge crosses the channel between Fourth and Fifth Lakes in the heart of Inlet. Fifth Lake is the smallest of the eight lakes in the Fulton Chain. At the far side of the lake is the beginning of a four-tenths-mile-long carry to Sixth Lake. The old iron bridge that leads to the South Shore Road has since been replaced.

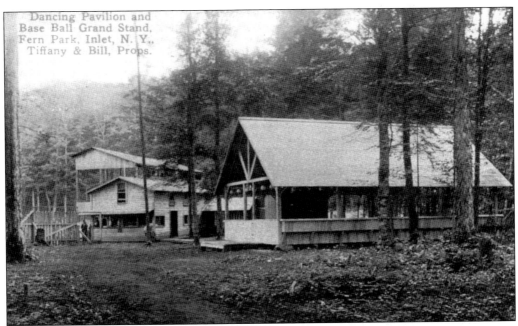

In Inlet, Fern Park has always been a place to gather for recreational activities. It is still the site of many games and concerts. Years ago, rollicking baseball games were held here between Inlet and Old Forge teams. Beautifully maintained hiking and cross-country ski trails begin and end at the park.

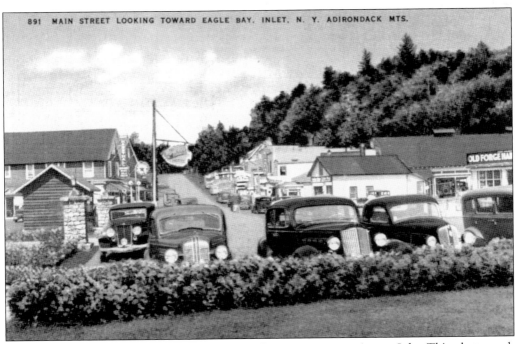

The paving of the state highway in 1926 brought many new tourists to Inlet. This photograph was taken looking south toward Eagle Bay. The signpost and stone pillars led to the Arrowhead Hotel, now Arrowhead Park.

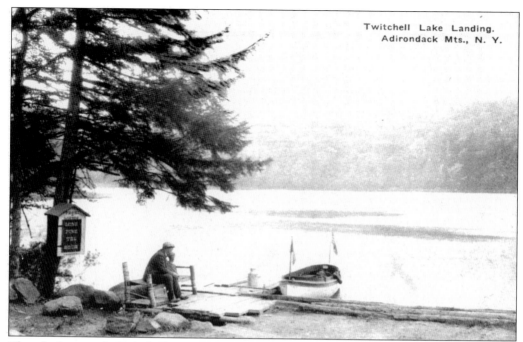

Twitchell Lake Landing.
Adirondack Mts., N. Y.

The telephone at the Twitchell Lake public dock linked callers to Lone Pine Camp, at the opposite end of the lake, where tea and pancakes awaited visitors. Among the other public establishments in years past was Earl Covey's Twitchell Lake Inn. Today, most camps on remote Twitchell Lake are privately owned and accessible only by boat.

Early maps spelled Limekiln Lake as Lime Kiln, which referred to a commercial enterprise that burned limestone to make mortar. In its heyday, Limekiln Lake was a bustling community with two large hotels, a general store, a post office, and nearly 50 cottages. Most of the lakeshore is now state owned, and a public campground was established in 1963.

Lake associations provide seasonal residents an opportunity to socialize, express their concerns, and work together for the betterment of their lakeside communities. The Seventh Lake Association, later expanded to include Sixth Lake, began in 1939 and is one the area's oldest lake associations. Sparsely populated Seventh Lake is often called the most beautiful body of water in the Fulton Chain.

Eighth Lake is unique among the lakes of the Fulton Chain because it is entirely surrounded by state lands. A public campground, established in 1935, is nestled in among the trees at the southern end of the lake. A stand of giant virgin trees called Cathedral Pines is a popular nearby hike, with access from the state highway between Seventh and Eighth Lakes.

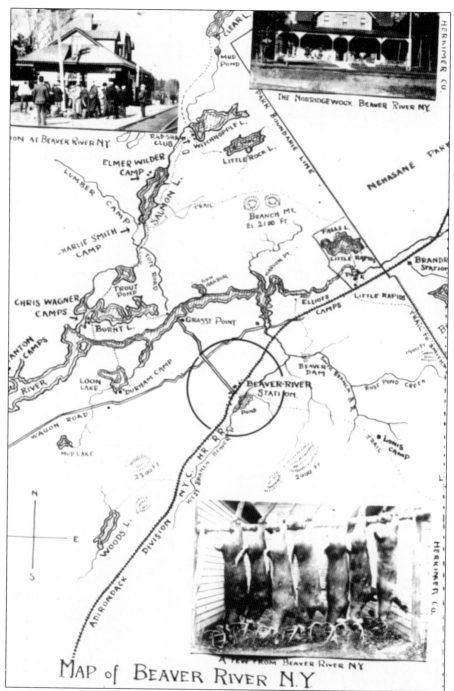

MAP of BEAVER RIVER N.Y.

In 1964, when the railroad ceased passenger service, Beaver River became the most isolated hamlet in the region. Since the beginning of the 20th century, the Norridgewock has been a focal point in this former booming logging community. Four generations of the Thompson family have operated this business as a lodge, post office, general store, cocktail lounge, and restaurant. The one-room schoolhouse, which also served families from Brandreth Station and Nehasane, survives and is owned by the Partridge family, pioneer Beaver River settlers.

Nine

ODDS AND ENDS

Postcards provide an important visual link to our past. Adirondack photographers captured extraordinary images of the people, places, and events that shaped our unique regional history. According to many writers, the period from 1905 to 1915 was considered the golden age of postcards. During these years, up to one billion cards were mailed annually in the United States— 10 times the national population of the day (Bogdan, 1999).

The bathing beauties in the photograph below appear to be playing water seesaw. The artful and provocative postcard was sent in 1907 from Jenie M. to her employer Mrs. Delmarsh at Cedar Island Camp. Jenie was called home to care for her ailing father in Lyons Falls. Losing a valued employee in "high tourist season" was as perilous a situation then as it is today. This chapter brings together an assortment of cards that illustrate vistas, groups of people, humor, or unique architectural structures that defy categorization.

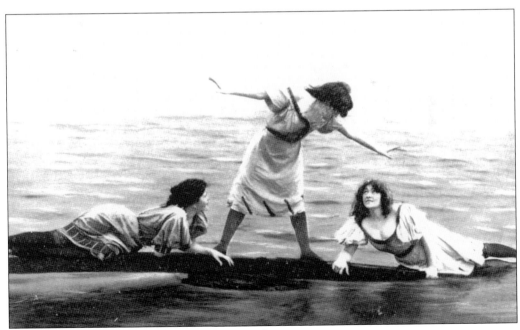

Three bathing beauties model stylish swimsuits from a century ago.

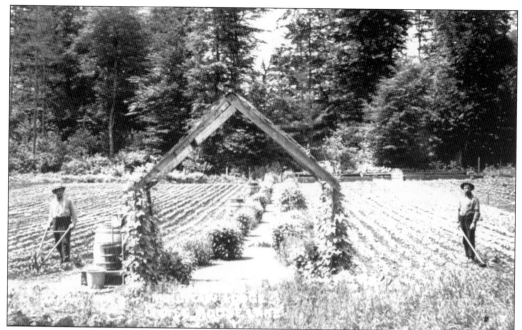

A vegetable garden is a rare sight in the central Adirondacks. The combination of poor soil, a short growing season, and "hungry critters" makes the growing of vegetables exceedingly difficult. Fresh produce was a high priority at the Adirondack League Club, where years ago local folks were hired to cultivate this beautiful garden.

Henry Covey, builder of Camp Crag, became a permanent resident of Big Moose Lake in the late 1880s. He was appointed the first Big Moose postmaster in 1893. Careful scrutiny of this card leaves one to wonder . . . are these Camp Crag guests or employees?

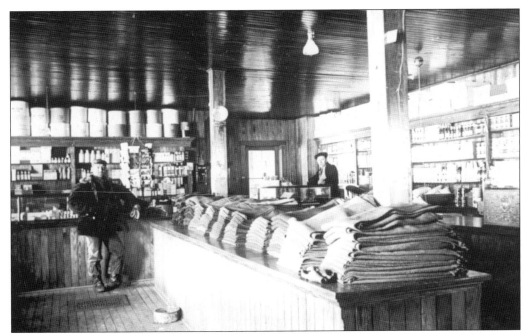

The incredibly well-stocked shelves of the Mac-A-Mac Company Store at Brandreth Station included plenty of woolen pants, tins of tobacco, and bug dope. The merchandise was sold to the numerous workers hired to log old-growth conifers in Brandreth Park. Today, Brandreth Station is a ghost town.

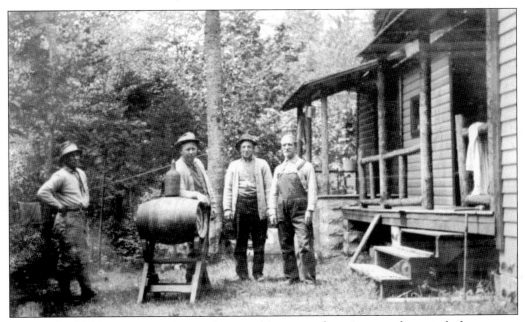

During Prohibition, rumrunning and moonshine manufacturing supplemented the meager incomes of some Adirondack families. This photograph of a home brewery was taken deep in the woods near Twitchell Lake . . . far from the eyes of the law.

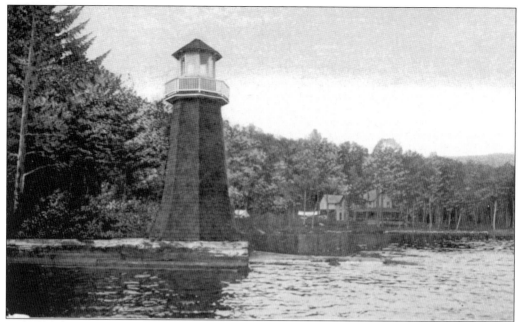

Shoal Point Lighthouse, on the north shore of Fourth Lake, was built during the heyday of steamboat travel on the Fulton Chain. In 2001, the lighthouse was restored with funds collected by the Fourth Lake Property Owners Association. Once again, it is operational.

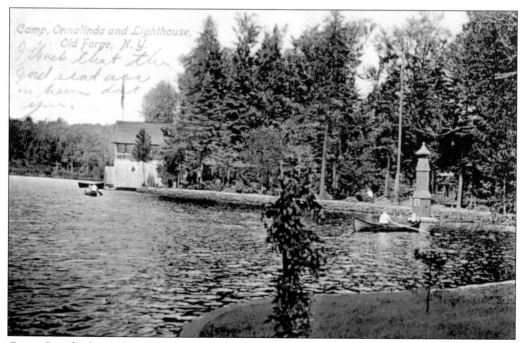

Camp Onnalinda was located on the south shore peninsula of Old Forge Pond. This small shingle-sided lighthouse on the camp property has been painted yellow and is a familiar landmark on the pond today.

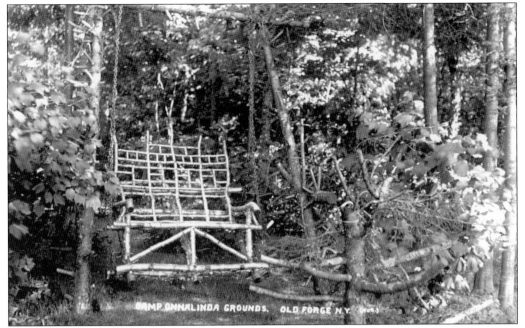

Local carpenters handcrafted decorative rustic furniture for camp owners. Materials were harvested from the surrounding forests. A few of these fine pieces have survived and are on display in Adirondack museums. A revival of interest in rustic furniture has inspired a whole new generation of craftsmen.

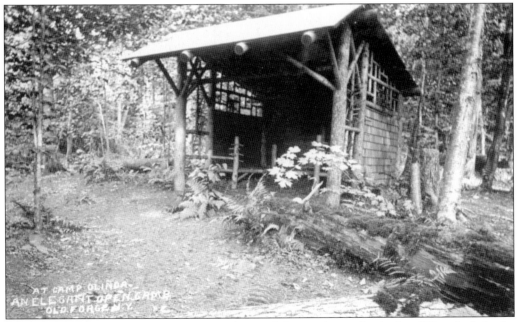

This artistic open camp at Onnalinda was designed for picnics or tête-à-têtes. When built in the 1890s, Camp Onnalinda was an extraordinary example of the newly popular rustic architecture style. The origin of the camp name remains a mystery.

Many camps and hotels built shoreline gazebos. These two were located on the Bald Mountain House property for the enjoyment of the guests. Although only a few old gazebos survive, there is a renaissance of interest in them, especially when screened to keep out blackflies and mosquitoes.

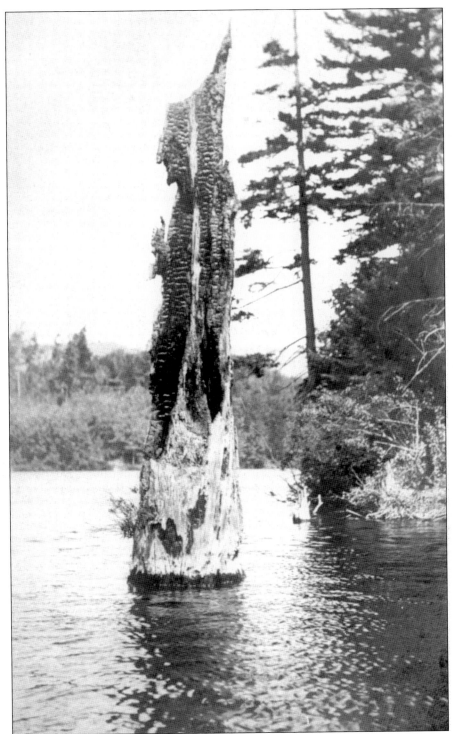

The Witch Tree was a well-known landmark in the channel between Second and Third Lakes. Although most of the tree has disintegrated, a small piece does remain. Its phantasmagorical shape has long been the basis for campfire tales.

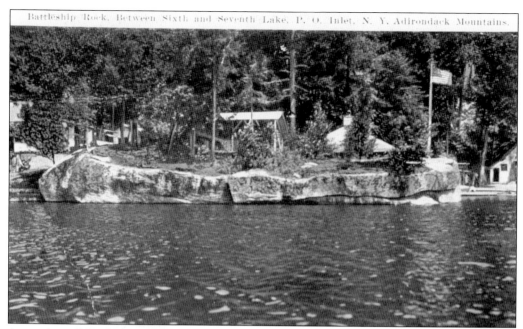

A number of local geographic placenames originated in the imaginations of early explorers. Often there was a tendency to anthropomorphize a feature, resulting in such novel names as Gooseneck Lake, Dollar Island, Elbow Pond, or Flatrock Mountain. This interesting formation is called Battleship Rock.

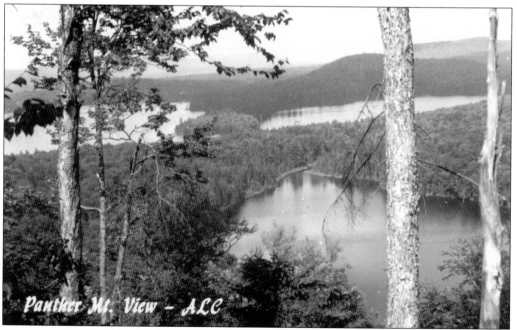

The timeless view from Panther Mountain overlooks the unspoiled wilderness of Panther and Little Moose Lakes. Ironically, there have been no documented sightings of panthers in the Adirondacks for at least 100 years.

Intrepid 19th-century explorer Nicholas Stoner found this shimmering body of water teeming with fish and kept secret its location for a number of years. Nearly 200 years later, it bears his name. Nick's Lake is the site of a very popular New York State public campground.

DOWNTOWN OLD FORGE. N.Y. AT NIGHT

These two last scenes are familiar ones to anyone who knows Old Forge.

OLD FORGE, N.Y. IN WINTER